THE POOLE COLLECTION

THE POOLE COLLECTION

One of the most comprehensive groups of 18th and 19th century
English sporting scenes to be held by a private collector.

66 COLOR PLATES

ISBN 0-9603880-0-1

Designed by Nancy J. Updike
Edited by Julie Britt

CONTENTS

The first cardinal rule of forming an art collection of any kind is to get the best advice available. The way that Mr. and Mrs. William Poole set about building their remarkable collection of British sporting art could well serve as a model for other collectors to follow. Rather than try to go it alone, they sought the advice and guidance of two well-established New Orleans dealers, Warren Casey and Kurt Schon. Together they planned to assemble a representative collection of the best English sporting painters of the 18th and 19th centuries. In remarkably few years, and with a limited budget, they put together a collection that includes major works by Stubbs, Ben Marshall, Henry Alken, John Ferneley, John Frederick Herring, and many others. The collection is still very little known, which is one of the reasons for publishing this book. Also, it is planned to exhibit the collection at several American museums, which will certainly establish its importance as one of the most interesting collections of English art in the U.S.A. One thing it has already proved is that its value is far in excess of the original outlay.

Many people feel that putting together an important art collection is something beyond them, both artistically and financially. In fact, this is not the case. With a limited budget, and advised by a reputable dealer, anyone can put together a collection of real interest and lasting value. There are certain simple rules to be followed. Firstly, it is obviously important to get expert advice, and the dealer selected must be well-established and of a proven reputation. Secondly, it is important to choose an area of specialization. The range of schools and periods of art is so great that only museums can collect on an international scale. The collector must look for some particular theme, period, or school of art that appeals to him. Thirdly, the personal response is important. Never collect art for investment alone. The greatest reward to be gained from collecting is to buy things that give one real pleasure to own and enjoy. In other words, collecting should be fun.

With their interest in animals and in sport, the Pooles decided to collect English sporting paintings. Obviously, the marketplace for pictures like these is in London, and most of the purchases were made there through an agent of Kurt Schon. Although some of the pictures may have been bought from private sources or other galleries, the bulk of them were bought from either Christie's

or Sotheby's auctions. Both these prestigious firms—the two leading auction-houses in the world—guarantee the authenticity of the objects they sell...thus the quality is correctly catalogued by experts in the field. Condition is another important element in paintings, and this was checked in each case by Mr. Schon's firm. Any cleaning restoration or reframing necessary was also carried out in London, which is fortunate in having a great tradition of craftsmanship in the conservation of works of art.

At the heart of the collection are two paintings by George Stubbs, now recognized as England's greatest animal artist. One is of a saddled hunter, the other of two hunters out to grass. Next in importance come three remarkable Ben Marshalls, one of a hunter, the other two of famous racehorses, Mameluke and Zinganee. The 18th century part of the collection is completed by an out-standingly fine George Morland "The Benevolent Sportsman" and a J. N. Sartorius. The tradition of English sporting art reached its peak during the Victorian period, and it is here that the bulk of the collection is concentrated. Abraham Cooper, R. B. Davis, Harry Hall and John Ferneley are of course well represented, but in particular John Frederick Herring, Senior, of whom the Pooles have no less than ten examples. These range from racehorses to farm scenes, studies of dogs and other animals as well. These subjects were also ably painted by his son, J. F. Herring Junior, until recent years a much neglected artist. Another artist much favored by the Pooles is George Wright, a later Victorian painter of hunting and coaching scenes. There is a good group of five works by him. Other painters of hunt-ing scenes represented include Thomas Blinks, Heywood Hardy, E. B. Herberte, Samuel E. Waller, John Sanderson Wells and Alfred Wheeler. William Sextie is another artist neglected until recently, and the Pooles have three good examples by him. It is important in any collection to have the well-known names, but also to explore some of the lesser-known ones, too. For it is the neglected artists of today who may become the heroes of tomorrow.

In addition to hunting and racing scenes, the Pooles are obviously fond of coaching subjects. This was also a sturdy tradition in English art during the late 18th and 19th centuries, the most famous exponent being James Pollard. But even

after the coaches had long since disappeared from English roads, there were artists who continued to recall the coaching days of the past. One of the best of these was John Charles Maggs, who is represented in the Poole collection by no less than ten examples. Many of these are winter scenes, with coaches struggling through the snow, a subject which always seems to appeal to those who live in warmer climates than that of England.

It has taken just five years to put this collection together, which shows what can be done if a collector has both the means and the determination to find what he is looking for. It is of course the result of an ideal collaboration between collector and dealer, the collector providing the means and the enthusiasm—the dealer providing the expertise and the knowledge. Although the Pooles have now almost completed their collection, they are still occasionally acquiring new works to fill in gaps. For once the collector has been bitten by the collecting bug, he is unlikely to stop altogether. When the collection has been published and exhibited, I feel sure that the Pooles will receive proper credit for their remarkable achievement. I also hope it will act as an inspiration for others to follow in their footsteps.

Christopher Wood, 1979

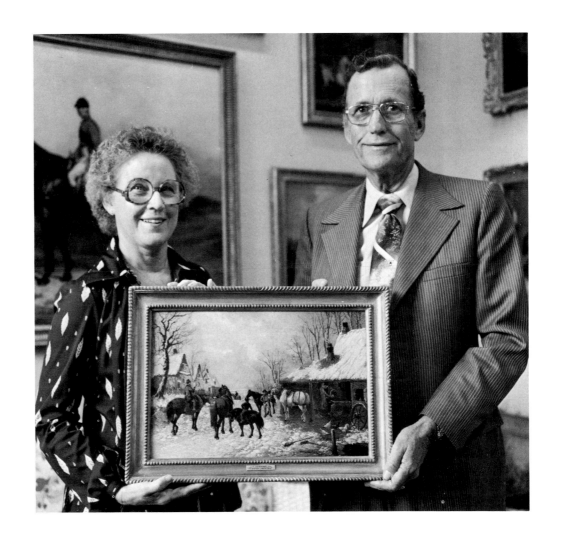

8

To assemble such a collection could be described as a coup, an accomplishment very few people have the vision, tenacity and resources to achieve. How it began may give insight to others.

William Poole could hardly be described as a typical patron of the arts. He started life as a farm boy in Nueces County, Texas, in meager surroundings, where the family worked hard for a living. He grew up with horses and took pleasure in hunting and fishing. He attended Texas A & M, and Corpus Christi Business College. From a first job as a truck driver for a drilling company in the Texas oil fields, to working on a drilling rig, Mr. Poole next learned to fly a plane. He became assistant manager of Cliff Maus airport in Corpus Christi, and with the coming of World War II he joined the Army as a flight instructor, and then as an air transporter. After the war, he joined Appell Drilling Company as a pilot and office manager, moving up to general manager and drilling superintendent.

Eighteen years later, Mr. Poole took a major step in his career with the founding of Choya Drilling Company, named for a type of cactus familiar to the land Mr. Poole knew so well. His long experience with oil, the drilling and exploration for it, turned Choya into a most profitable enterprise...and made the farm boy not only very wealthy, but also one of the most prominent businessmen in Texas.

With his time devoted to his profession, it was his wife, Evalyn, who initially pursued an interest in the fine arts, dabbling in creative painting herself. Her interest in art brought her into contact with Mr. J. Warren Casey, owner of a fine art gallery in New Orleans' French Quarter. Mrs. Poole was very receptive to Casey's suggestions of acquiring fine art masterpieces, but her husband's business acumen initially made him cautious. With a businessman's perception, he realized that this was not a field to leap into without proper understanding or previous experience in the art market. To enjoy art was one thing, but to tie up a sizeable part of one's fortune in painted canvases could be a venture fraught with apprehension.

Months of planning then went into the formulation of a format for collecting to be submitted to Mr. Poole. Art dealer Casey refers to this as a period of incubation. "It was an exciting challenge for us to put together a plan for a rare collection of fine art that would bring renown to the collector and represent a sound

business investment with maximum opportunity for appreciation in value. During this time, I was diligently working with Kurt E. Schon, an art dealer of international reputation, with whom I maintain an active association. Mr. Schon has worked for years with art representatives in Europe and keeps close contact with experts in the leading auction houses, Christie's and Sotheby Parke-Bernet. He is also the owner of one of the largest fine art galleries in the South and counts among his clientele many of the leading collectors in the Americas."

Upon reaching an agreement with Mr. Poole to establish a collection of English sporting paintings, Messrs. Casey and Schon spent the next five years working with several experts in Europe, searching for every opportunity to add scope and stature to the collection. The goals had been carefully set, and extensive studies were made of the artists, exhibition records, and provenance of each painting. During the assembly of the collection, the Pooles were frequent visitors to New Orleans to see each work and decide upon it.

Relying on the expertise of Messrs. Schon and Casey, Mr. Poole was not long in deciding whether to purchase a painting for the collection or not. When he saw something he liked, his decision to own it was made in minutes, fully confirmed by the nod of approval from Mrs. Poole

With their collection virtually complete, the Pooles wanted to share their enjoyment of these paintings with others. A nation-wide museum tour was arranged so the collection could be exhibited to the public.

This collection of sporting scenes reflects the interest of a man raised in the rolling hill country of Texas, a lover of sports and horses and fine cattle. Mr. and Mrs. William O. Poole can truly view their collection with pride. They have realized a fine accomplishment in owning a collection of art that could rival the holdings of many museums.

Notes from an interview with Mr. William Oliver Poole, his wife Evalyn. and Mr. J. Warren Casey, March 28, 1979, at the gallery of Mr. Kurt E. Schon, New Orleans, Louisiana.

THE POOLE COLLECTION

GEORGE STUBBS, A.R.A. (1724-1806)

George Stubbs was born the son of a Liverpool tanner in 1724. The young Stubbs showed an early interest in anatomy, though he received little formal education in art. From 1744-1753 Stubbs earned a living by painting portraits in the North of England. During this period he also lectured on human anatomy to students at York Hospital and drew and etched illustrations for a book on midwifery.

In 1854 he visited Italy and for the next four years Stubbs was engaged in the monumental work for his book, *The Anatomy of the Horse,* doing dissections, writing and illustrating it single-handedly. After he came to London, Stubbs quickly found himself the centre of attention among a group of aristocratic patrons, young, rich and keen to make their mark. Many were members of the recently-founded Jockey Club. That he painted their horses was almost a foregone conclusion, for these were being bred to an increasingly high standard of excellence and growing international fame.

In 1780 Stubbs was elected A.R.A. and in the catalogue for the exhibition in 1782, he was styled as "R.A. Elect". Unfortunately all seven of his contributions for that year were so badly hung that the irascible Stubbs was enraged and refused to comply with the requisite formalities for his election to R.A. Thus he was never more than an "Associate", though for the rest of his life Stubbs always styled himself "Academician".

Stubbs loved to paint exotic wild animals, while his conversation pieces of 18th century country gentlemen with their horses and hounds have never been bettered. His knowledge of the anatomy of his subject and the rhythm of his composition, combined with his superb draughtmanship and sympathy with his subject, raised him far above other animal painters. Stubbs is without a doubt one of the greatest English animal painters.

Right: *A Saddled Bay Hunter in a Landscape with a Lake Beyond*
Oil on panel, 27¾" x 29¼". Signed and dated 1786.
Provenance: Lt.·Col. R. Myddleton, Chirk Castle.

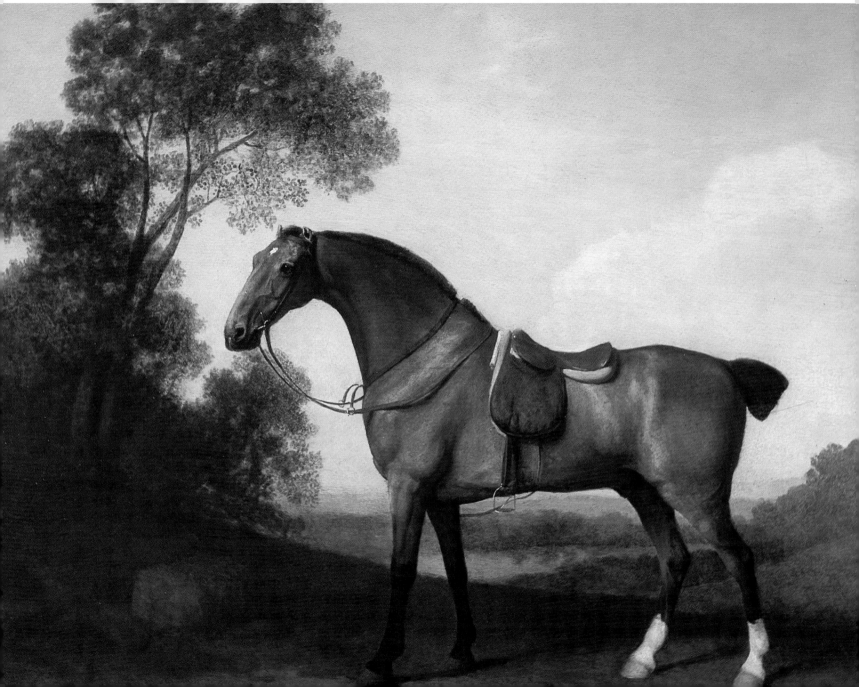

GEORGE STUBBS
Right: ***Two Hunters Out at Grass***
Oil on panel, 35″ x 53″. Signed and dated 1788.
Provenance: Lord Valentia. C. Kleinwort. The Beaverbrook Foundation.

14

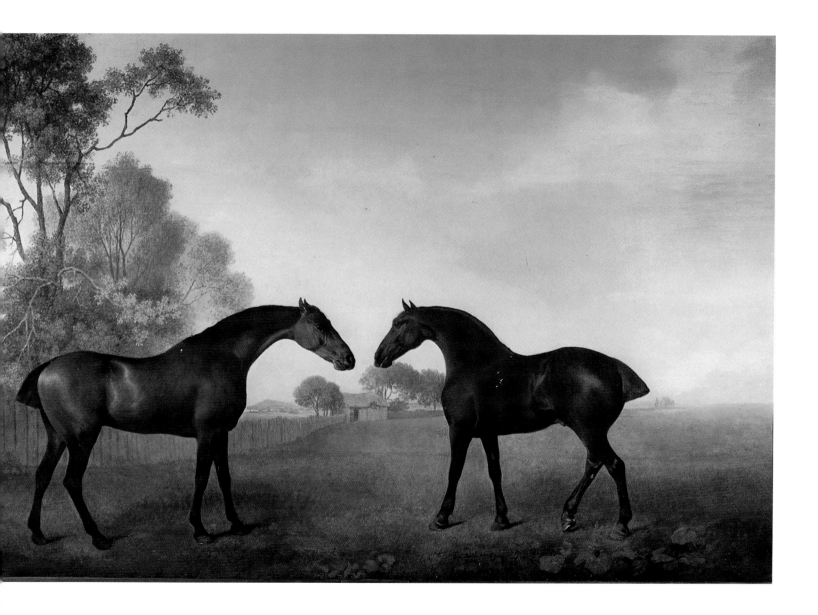

GEORGE CHARLES MORLAND (1763-1804)

George Charles Morland, the son and grandson of artists, was born in London in 1763. Morland first exhibited at the Royal Academy at the age of ten. Although always a Londoner, he visited Kent, the Southern Counties, the Isle of Wight and once went to France. His career was divided fairly equally between hard work and hard drinking, although his dissolute way of life may well have been exaggerated by his upright Victorian biographers. However, it is known for certain that he often preferred quick drawings and sketches as payment for food and drink. Morland's fame and popularity were helped by his friendship and double relationship with the Ward family—he and William Ward married each other's sister.

The horses that Morland painted with such realism were the equine equivalents to his rustic humans: rough and hard-working. Morland's best paintings were perhaps his compositions with animals and small groups of peasants and other people in wooded landscapes.

Although Morland, from time to time, received comparatively large amounts of money from engravers and private commissions, he was arrested for debt in 1799 and ultimately died in a London sporting house in 1804. During his lifetime, Morland exhibited 38 works at the Royal Academy.

Right: ***Morning; or The Benevolent Sportsman***
Oil on canvas, 42½″ x 56½″.
Provenance: Commissioned by Colonel Stuart in 1791 for 70 guineas.
J. E. Fordham, Melbourne Bury, Royston. Sir Joseph Beecham, Christie's, May 3rd 1917. Lot 46, bought Robson, 5,200 guineas.
Exhibited: Royal Academy, 1792, No. 23. International Exhibition, 1862, No. 103. Franco-British Exhibition, 1908, No. 48. International Exhibition, Rome, 1911, No. 65.
Literature: G. C. Williamson, "George Morland", 1904, p. 52.
Engraved: J. Grozer, 1795.

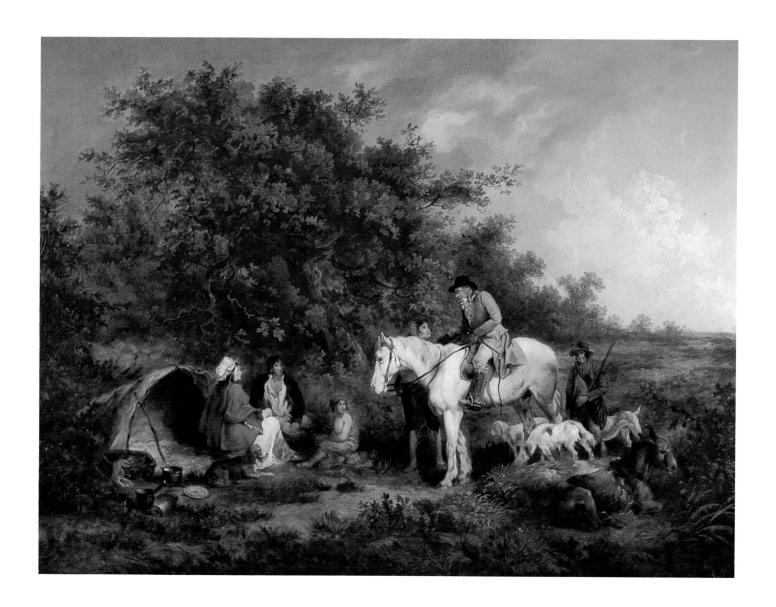

BEN MARSHALL
(1767-1835)

Ben Marshall, born in 1767, initially studied portraiture under Lemuel Francis Abbott. However, he resolved to paint sporting subjects after seeing Sawrey Gilpin's striking picture, *The Death of the Fox*. A lucky association with John Scott, the engraver, led to a long series of plates being published in The Sporting Magazine. In this way, Marshall's name was brought before a wide public and attractive subjects were laid before him by many wealthy patrons. After settling in Newmarket, to be close to the center of the racing world, Marshall joked with Abraham Cooper, "I have a good reason for going. I discover many a man who will pay me fifty guineas for painting his horse, who thinks ten guineas too much for painting his wife!"

Marshall introduced portraits and likenesses of jockeys, grooms and stable boys into his pictures; all of which help to vividly capture the 19th century racing scene. His vigorous approach to his paintings was something of an innovation and his flair for making the muscular elegance of a racehorse stand out from the canvas, brought him general acclaim and many valuable commissions.

In 1819, Marshall suffered terrible injuries when travelling in the Leeds coach which overturned because of the drunkenness of the driver. His artistic skill was seriously impaired and many feared that his career as a painter was over. However, just two years later he was courageously building a new studio and went on to produce outstanding portraits of such horses as 'Mameluke', 'Zinganee', and many others.

Right: *A Bay Hunter in a Landscape*
Oil on canvas, 28¼" x 36". Signed and dated 1799.
Provenance: Lady Wiley.
Literature: Aubrey Noakes, "Ben Marshall", 1978, p. 31, no. 24, pl. 39.

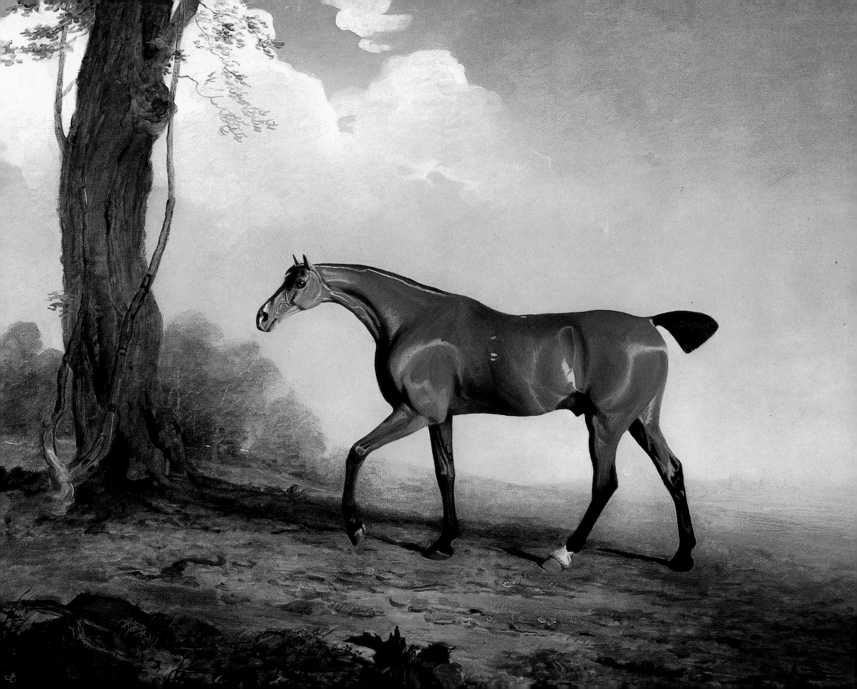

BEN MARSHALL
Right: *'Zinganee', Held by Sam Chifney Junior at Newmarket*
Oil on canvas, 39" x 49½".
Literature: The Sporting Magazine, Vol. II, 2nd Series, 1831, pl. 1. The Sporting
Magazine, Vol. XXIV, 2nd Series, 1842, p. 266. Compare Aubrey Noakes,
"Ben Marshall", 1978, p. 53, no. 193, pl. 12. See Aubrey Noakes, "Ben
Marshall", 1978, p. 58, no. 264a, pl. 19.

*'Zinganee', a bay colt by 'Tramp' out of 'Folly' was foaled in 1825 and bred by
the Marquess of Exeter, who sold him to William Chifney in 1827. 'Zinganee'
was third in the famous Derby of 1828 when 'Cadland' and 'the Colonel' dead-
heated; the same year he won the Newmarket Stakes. In 1829 he won the
Craven Stakes and the Oakland Stakes at Ascot. 'Zinganee' was subsequently
bought by Lord Chesterfield for whom he won the Ascot Gold Cup. In 1830
he was sold to Mr. Delme Radcliffe and later to George IV. In 1836 'Zinganee'
was exported to North Carolina where he stood at stud. The Sporting Magazine
described how "The Lexican (Kentucky) Observer mentions the death of the cele-
brated horse 'Zinganee' whilst at play, he slipped and broke his off hind leg".*

*Samuel Chifney Junior (1786-1854) was the younger son of the celebrated
jockey Samuel Chifney Senior and brother of the famous trainer, William Chifney.
As much as natural horseman as his father, Chifney Junior went on to become a
still greater jockey. He was a brilliant judge of pace and could produce a storming
finish, the famous "Chifney rush" pioneered by his father, with perfect timing
at the end of a race.*

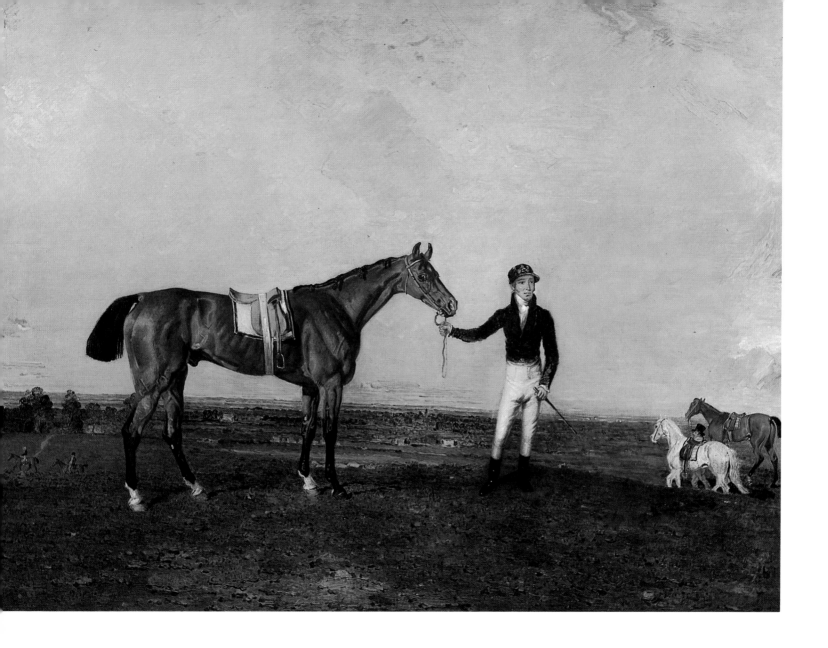

BEN MARSHALL
Right: *'Mameluke', A Bay Racehorse Held by His Trainer, Edwards, with*
a Groom Nearby on the Epsom Downs, with the Racecourse in the Distance
Oil on canvas, 29″ x 35½″. Signed, inscribed and dated 1827.
Provenance: Probably Christopher Wilson Esq. (1763-1842). Mr. and Mrs. Charles Robson.
Fletcher Jones Esq.
Literature: Compare Sir Walter Shaw Sparrow, "British Sporting Artists", 1922, p. 175.
Compare Sir Walter Shaw Sparrow, "George Stubbs and Ben Marshall", 1929, pp. 72-3.
Aubrey Noakes, "Ben Marshall", 1978, p. 51. no. 188, pl. 18.

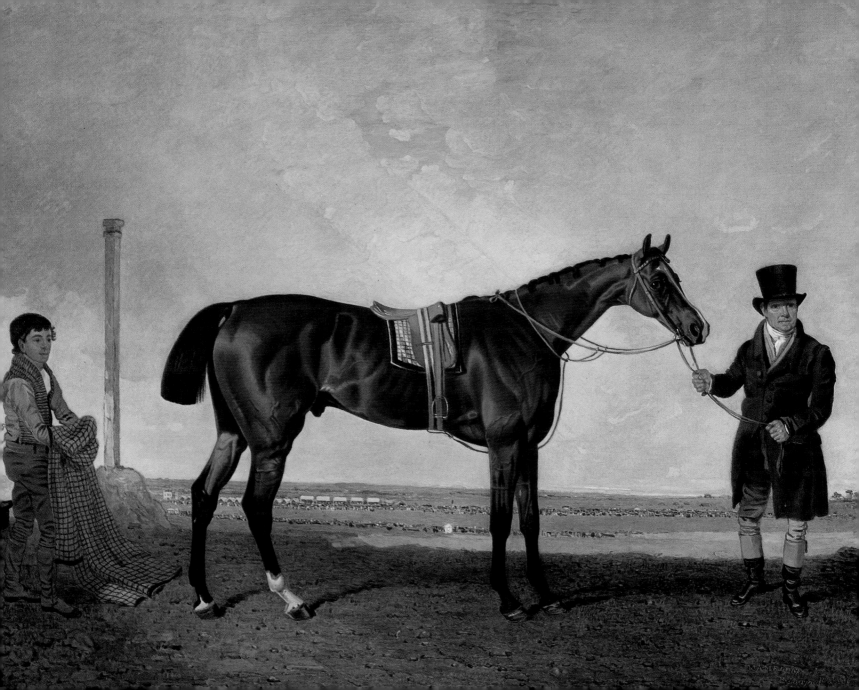

ABRAHAM COOPER, R.A. (1787-1868)

Abraham Cooper was born in London in 1787 and was a painter who specialized in sporting and battle pictures. Cooper started at the age of thirteen as a scene painter and illustrator for a circus. He was largely self-taught, though at age 22 he was introduced to Ben Marshall, who took him into his studio and gave Cooper a few free lessons. Abraham Cooper first exhibited his work at the British Institution in 1814. He was elected A.R.A. in 1817 and then R.A. in 1820. Cooper exhibited the prodigious total of 322 works at the Royal Academy and 74 works at the British Institution. He was among the first rank of animal painters of his age, and his pupils include John Frederick Herring Senior and William Barraud. Cooper died at Greenwich in 1868.

Right: *An Equestrian Group with John Gully on his Hack; to the Right, 'Andover' with Alfred Day Up; and Center, 'Hermit' with John Wells Up.*
Oil on canvas, 35″ x 49½″. Signed with monogram, inscribed and dated 1854.

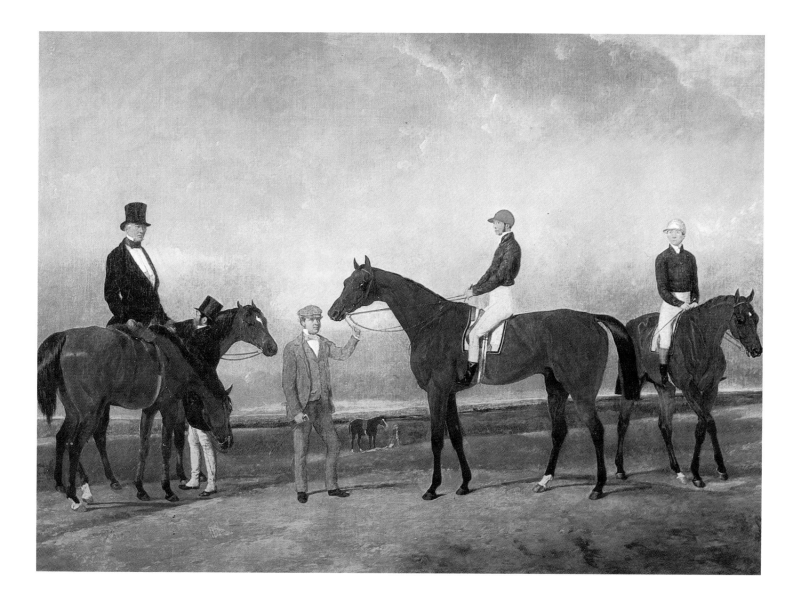

Right: *Portrait of John Gully, Half Length, Wearing a Blue Coat and White Stock*
Oil on canvas, 29½" x 24½".
Provenance: Anon. Sale; Christie's, October 25, 1957, Lot 163.

Prizefighter, horse-racer, legislator and colliery proprietor, John Gully is shown in paintings by Abraham Cooper, R.A. (preceeding page), and Harry Hall (right).

John Gully was born in August 1783, son of a West Country publican. His family moved to Bath where his father became a butcher and he was brought up in this trade. With his father dying, the business gradually declined and at the age of twenty-one, Gully was thrown into the King's Bench prison in London for debt. A year later Gully was visited in gaol by Henry Pearce, the "Game Chicken", bare-knuckle champion of England. They sparred and the patrons of the ring were so impressed that they paid Gully's debts and he went into training to fight for the championship. The fight took place in October 1805 in the presence of an immense concourse of aristocratic spectators, including the future King William IV. The fight was a bloody affair and after 64 rounds Gully, who was nearly blind, could not continue. A few months later Pearce retired and Gully assumed the title.

Gully's reputation was so great that no challenger could be found until 1807, when Bob Gregson, the Lancashire giant, challenged him. This fight lasted 36 rounds until Gregson was unable to come to the mark. Gregson again challenged in 1808 and, though Gully had an injured left arm, the fight only lasted for 27 rounds until Gregson again could not continue. So Gully retired unbeaten to be landlord of The Plough, a tavern in Carey Street, London, and devote himself to being a betting man and a racehorse owner.

In 1827, after 'Mameluke' had won the Derby for Lord Jersey, Gully bought the horse for 4,000 guineas, intending to win the St. Leger. However, as the race approached, a great deal of money was being laid to win. The race started over an hour late and it was apparent that the starter had been bribed. It was known that 'Mameluke' did not possess the smoothest of temperaments and a series of false starts had been organized to unsettle the horse. Sure enough when the word "go" was finally given, 'Mameluke' was caught flat-footed well to the rear of the field. The fact that the horse ran at all was largely due to Gully's presence at the start with a cart whip. Although badly hit (he lost some 40,000 pounds in wagers), Gully was able to settle the following week. "It is convenient for you?"

asked one of his creditors. "It is always convenient," Gully replied, "but it is not always pleasant." One of the big winners was William Crockford who used his money to open his famous gaming house in St. James's. It is still open to this day.

In 1830, Gully became betting partner with Robert Ridsdale; and in 1832, they won the Derby and 100,000 pounds with St. Giles. After the race they quarrelled. Further disputes followed and, after an afternoon in the hunting field, Gully horsewhipped him. Ridsdale brought an action for assault and was awarded 500 pounds damages. Later that year Gully won the St. Leger with Margrave, taking 35,000 pounds in wagers.

During this period, Gully lived near Newmarket but in 1832 he bought Ackworth Park, near Pontefract, and was Member of Parliament for Pontefract until 1837. It was said that it was not so much his powerful oratory that swayed the votes towards a liberal interest as his foresight in placing barrels of beer in the streets on polling day.

In 1846, Gully won the Classics—the Derby and the Oaks—with 'Pyrrhus the First' and 'Mendicant' respectively, an event only once before accomplished in the annals of the turf.

The year 1854 proved to be possibly his greatest when he captured the Two Thousand Guineas with 'Hermit' and the Derby with 'Andover'. Both horses were trained at Danebury by Old John Day, and both ran in the Derby. 'Hermit' was ridden by Wells, acting as pacemaker for 'Andover' who had Old John's son, Alfred, in the saddle. With a first and a third in the Derby, Gully had a very profitable day indeed!

This was to be his last major win and he spent the remainder of his life with successful investments in land and collieries. Gully lived until 1863, but he had a narrow escape from death many years earlier in a duel with the redoubtable Squire Osbaldeston, described as the best pistol-shot in England. The Squire sent a bullet slap through Gully's hat: "Better through my hat than through my head," was Gully's only recorded comment on the incident.

He was twice married and had in all twenty-four children, twelve by each wife. John Gully died at the venerable age of eighty.

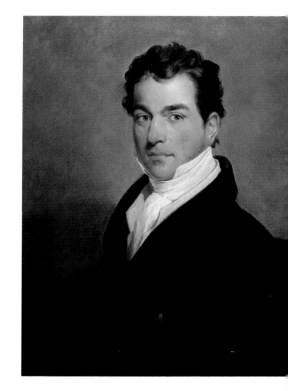

JOHN WOOTTON
(1686-1765)

John Wootton, an eminent English painter of landscapes and animals, was born towards the end of the 17th century. He excelled in sporting subjects, and in painting dogs and horses. He was much employed at Newmarket in painting the portraits of racers. He painted excellent landscapes in the styles of Claude Lorrain and Gaspard Poussin. He designed some of the illustrations in the first edition of Gay's "Fables," published in 1727. In his latter years his sight failed, and he died in London in 1765.

Right: *A Bay Hunter And A Grey Hunter Held By A Groom In A Landscape*
27" x 35".

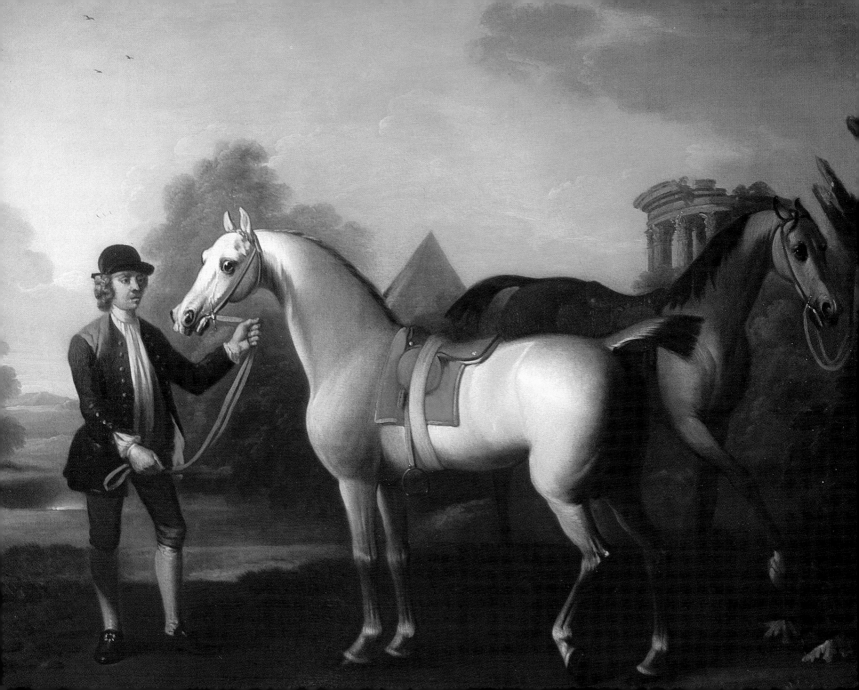

JOHN FREDERICK HERRING, SENIOR (1795-1865)

John Frederick Herring, Sr. was born in 1795, the son of an American fringe-maker in London. Herring started his working life as a coach painter before becoming a driver of stage coaches in Yorkshire. During this period he developed his natural ability as a painter by drawing horses and studying their anatomy. After retiring from the road, he studied for a short time as a pupil of Abraham Cooper, his only known formal training in art.

After living for a time in Doncaster, he moved in 1830 to Newmarket and gained rapid success in painting portraits of horses—in particular, winners on the Turf. Herring went on to paint, in all, 18 Derby winners and 33 successive winners of the St. Leger. He also painted many small studies of animals and many sporting and country scenes, often set in actual localities, but fewer coaching scenes than one would expect when considering his background. Herring received commissions from George IV, William IV and Queen Victoria, and he was appointed Animal Painter to the Duchess of Kent. He was, without doubt, the leading horse painter of his generation and remains one of the most generally popular, if not the most talented, of British animal painters. Herring exhibited 22 works at the Royal Academy and 82 works at the Society of British Artists in Suffolk Street.

Right: *'Satirist', William Scott Up, Beating 'Coronation', John Day Up, in the St. Leger, 1841, by Half a Neck*
Oil on canvas 12½" x 20". Signed, inscribed and dated 1841.

Lord Westminster's 'Satirist', a brown colt by 'Pantaloon' out of 'Sarcasm', was trained by the famous John Scott at Malton. Ridden by John Scott's younger brother, William, he won the 1841 St. Leger by just beating the odds-on favorite, 'Coronation', at 6/1. After that race Lord Westminster took his horses away from Scott. Certainly Lord Westminster had been greatly surprised by 'Satirist's' victory, unlike certain other supporters of the stable!

Mr. A. T. Rawlinson's 'Coronation', by 'Sir Hercules' out of 'Ruby', was a 5/2 favorite when he won the 1841 Derby. His position in the market was surprising as he was trained privately by his owner's stud groom, while his previous successes had been at minor meetings. After his Derby win he was treated like a spoiled child. It was probably through lack of condition that he was beaten by 'Satirist' when a 2/1 favorite for the St. Leger. He never ran again afterwards.

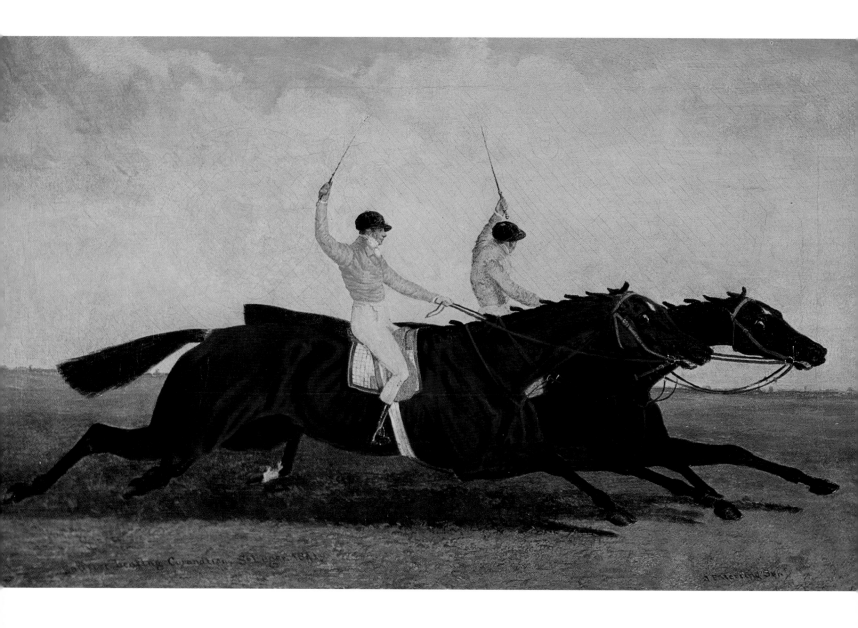

Don John beating Charles XII, St Leger 1841 J. F. Herring Sen.

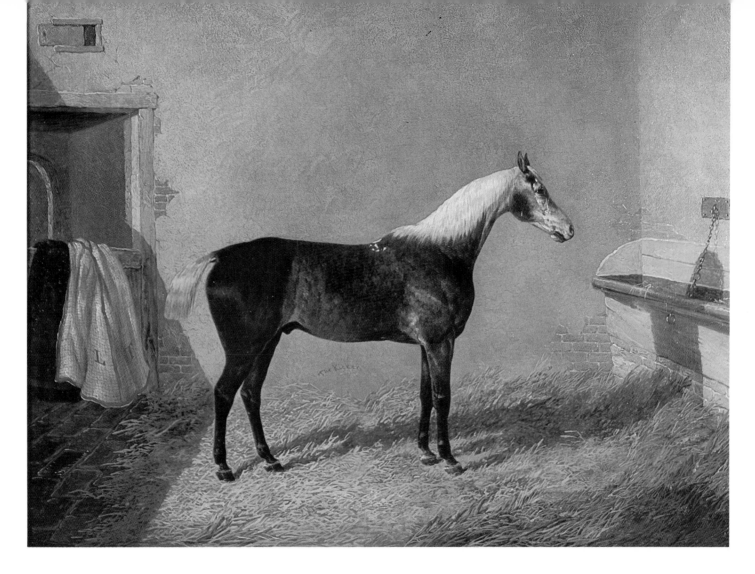

JOHN FREDERICK HERRING, SR.
Above: *'The Kicker', a Steel Grey Racehorse in a Stable*
Oil on canvas, 17¾″ x 23¾″. Signed, inscribed and dated 1845.

32

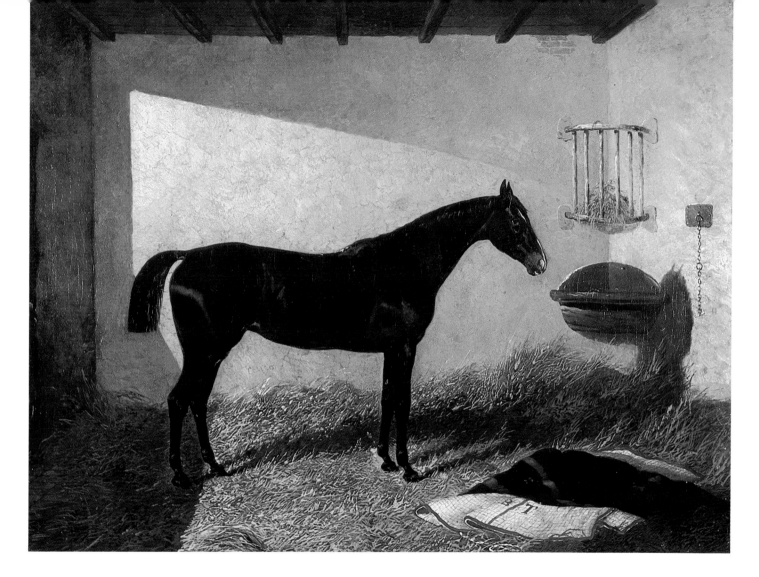

JOHN FREDERICK HERRING, SR.
Above: ***The Bay Hunter 'Happy Go Lucky' in a Stable***
Oil on canvas, 18″ x 24″. Signed and dated 1845.

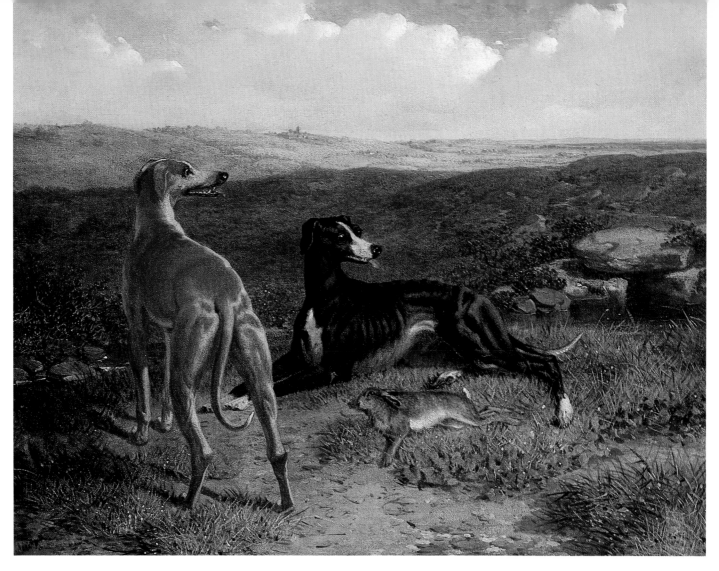

JOHN FREDERICK HERRING, SR.
Above: ***Two Greyhounds and a Hare by a Stream in an Open Landscape***
Oil on canvas, 13½″ x 17½″. Signed and dated 1865.

34

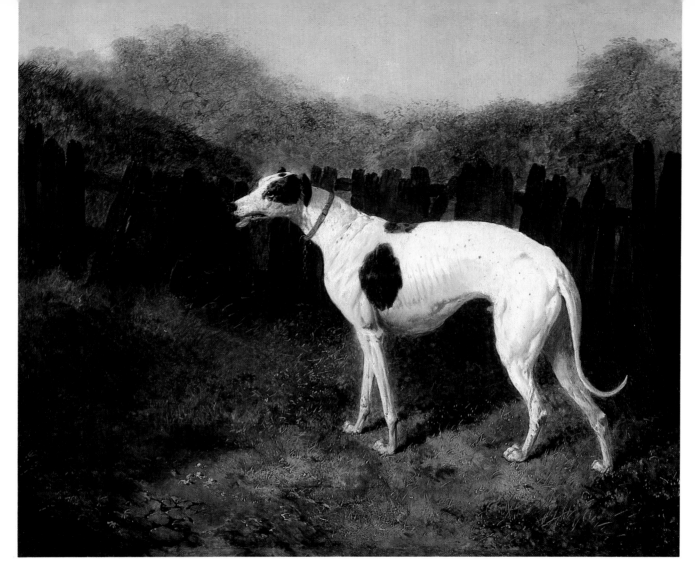

JOHN FREDERICK HERRING, SR.
Above: *A Greyhound in a Landscape*
Oil on canvas, 15½″ x 19¾″. Signed and dated 1855.

JOHN FREDERICK HERRING, SR.
Right: *'Cotherstone', the Bay Racehorse, in a Stable*
Oil on canvas, 13½" x 17½". Signed, inscribed and dated Derby, 1843.
Provenance: Thomas Sutherland Dawson, clerk of the course of the Northern Circuit.

'Cotherstone' was a bay colt by 'Touchstone' out of 'Emma'. He was a sickly specimen as a yearling and as a two-year-old was often amiss. However, during the winter of 1842-3 he made immense progress. So much so that, early in the spring, after an impressive gallop at home his owner, Mr. Bowes, backed him for the Derby to win 23,000 pounds. Long odds were available because the bookmakers thought they had a means of making the colt "safe"; but once the money was on, 'Cotherstone' was guarded like the crown jewels. Sent down to Newmarket, he won the Riddlesworth Stakes, the Column Produce Stakes, and then the Two Thousand Guineas. He started favorite for the Derby at 13/8 and, ridden by William Scott, he won by two lengths—much to the chagrin of those who had declared that because of his high, round action 'Cotherstone' would never be able to win the Derby "unless it was run upstairs."

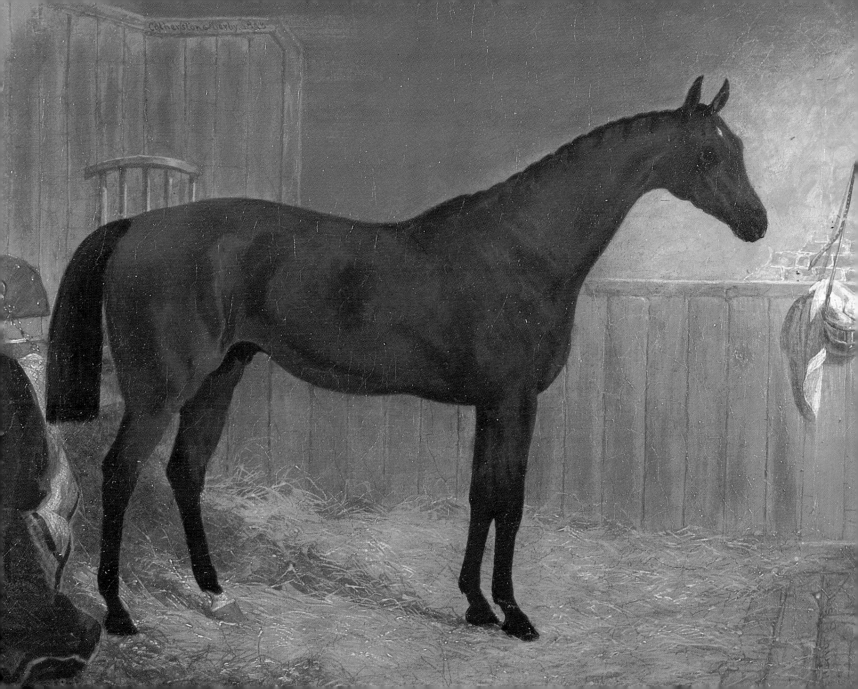

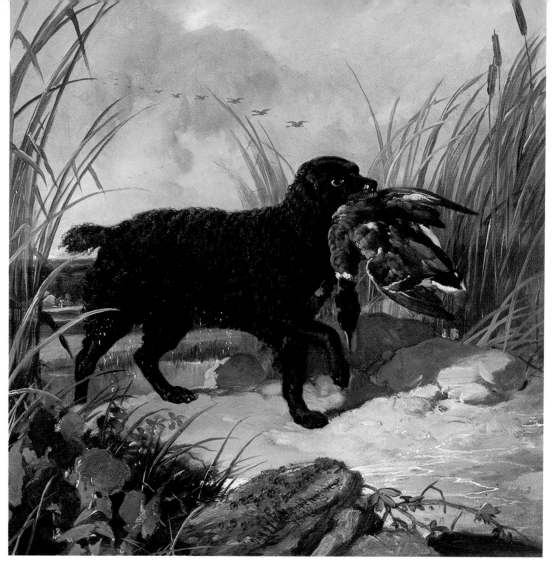

JOHN FREDERICK HERRING, SR.
Above: ***An Irish Water Spaniel Retrieving a Mallard***
Oil on canvas, 15½″ x 15½″. Signed and dated 1849.

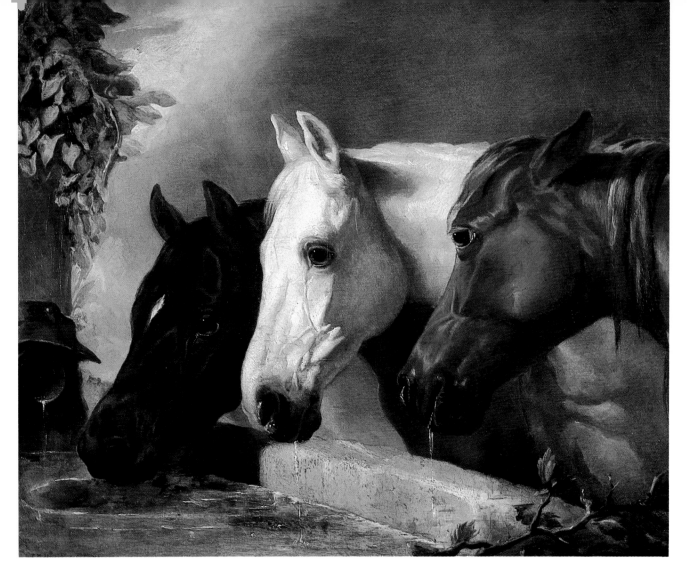

JOHN FREDERICK HERRING, SR.
Above: ***Horses at a Trough***
Oil on board—laid down, 24½″ x 29½″. Signed and dated 1842.

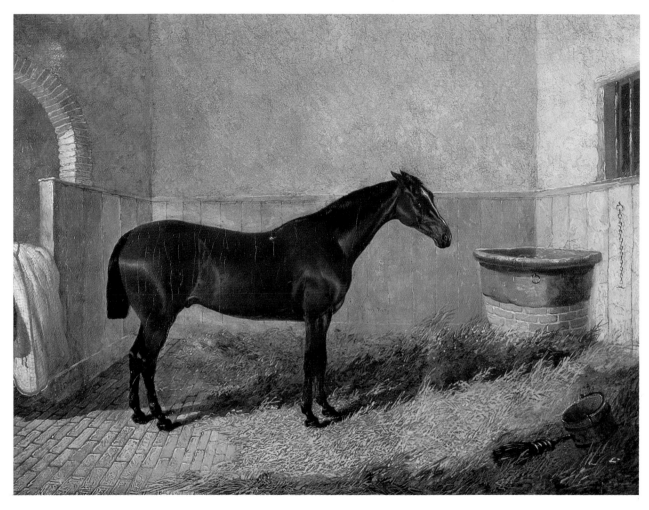

JOHN FREDERICK HERRING, SR.
Above: ***The Bay Hunter 'All My Eye' in a Stable***
Oil on canvas, 18″ x 24″. Signed and dated 1845.

40

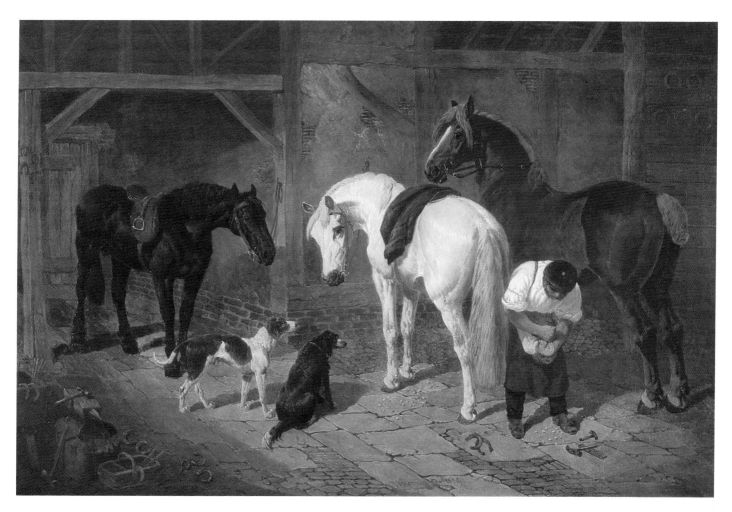

JOHN FREDERICK HERRING, SR.
Above: **The Farrier's Shop**
25″ x 38¼″. Signed and dated 1856.

JOHN FREDERICK HERRING, SR.
Right: *'Bay Middleton', the Racehorse in a Loose Box*
Oil on canvas, 9½″ x 13½″. Signed, inscribed and dated 1836.

'Bay Middleton' was a bay colt by 'Sultan' out of 'Cobweb'. He was a big horse and had a ferocious temper as well as a doubtful leg. He never ran as a two-year-old but was thought so promising by his owner, the 5th Earl of Jersey, that he was heavily backed to win the Derby before he had even done a serious gallop. In 1836, now a three-year-old, 'Bay Middleton' won the Riddlesworth Stakes and then the Two Thousand Guineas. Favorite for the Derby at 7/4, he was ridden by James Robinson and won easily by two lengths. After winning several more races, he was sold to Lord George Bentinck for 4,000 pounds. But shortly afterwards, the doubtful leg finally went and 'Bay Middleton' was retired to stud.

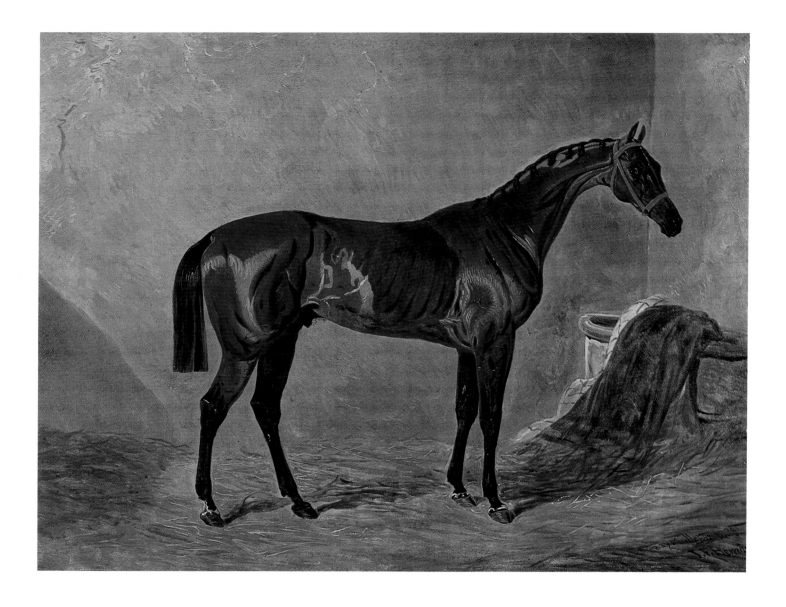

**JOHN FREDERICK
HERRING, SR.
(1795-1865)**

**HENRY BRIGHT, R.W.S.
(1810-1873)**

**CHARLES BAXTER, R.B.A.
(1809-1879)**

Collaborations such as this were not uncommon and the artists involved would each paint their particular specialty. In this painting the animals are by Herring, Sr., the castle and landscape background are by Bright, and the figures are by Baxter.

Henry Bright was a Norwich School landscape painter and watercolorist. He studied with John Berney Crome and John Sell Cotman. Bright exhibited 12 works at the Royal Academy and 11 at the Society of British Artists in Suffolk Street.

Charles Baxter was a London painter who was noted for his fancy portraits and paintings of charmingly pretty girls. He exhibited 45 works at the Royal Academy and 154 at the Society of British Artists in Suffolk Street.

Right: *The Cavalier's Visit*
Oil on canvas, 49¼″ x 39″. Signed by each artist and dated 1855-6.
Collection: Colonel J. J. Ellis, 1886.

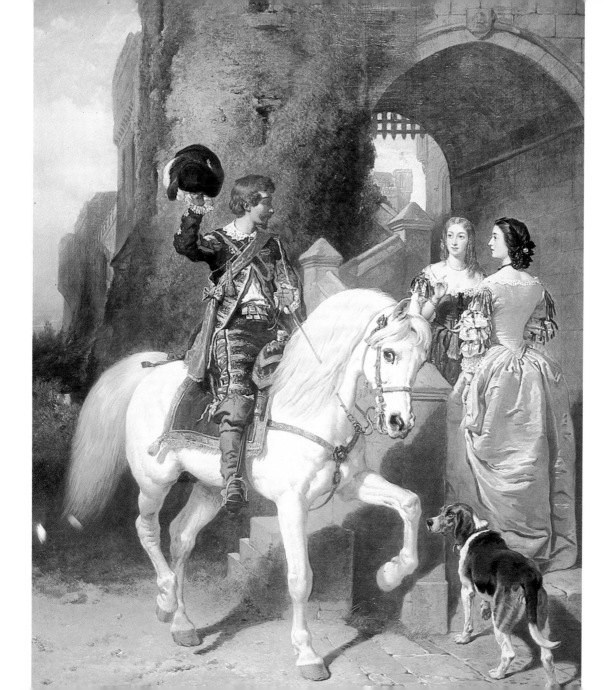

45

JOHN FREDERICK HERRING, JUNIOR (1815-1907)

John Frederick Herring, Jr. was a sporting and animal painter like his distinguished father, John Frederick Herring, Sr. Herring, Jr. studied under his father and certainly worked with him on paintings during the early part of his career. However, a serious quarrel with his father resulted in a rift between the two of them which never healed. Herring, Jr. exhibited three works at the Royal Academy and 55 works at the Society of British Artists in Suffolk Street.

Right: *A Winter Landscape*
Oil on canvas, 11½" x 17½". Signed.

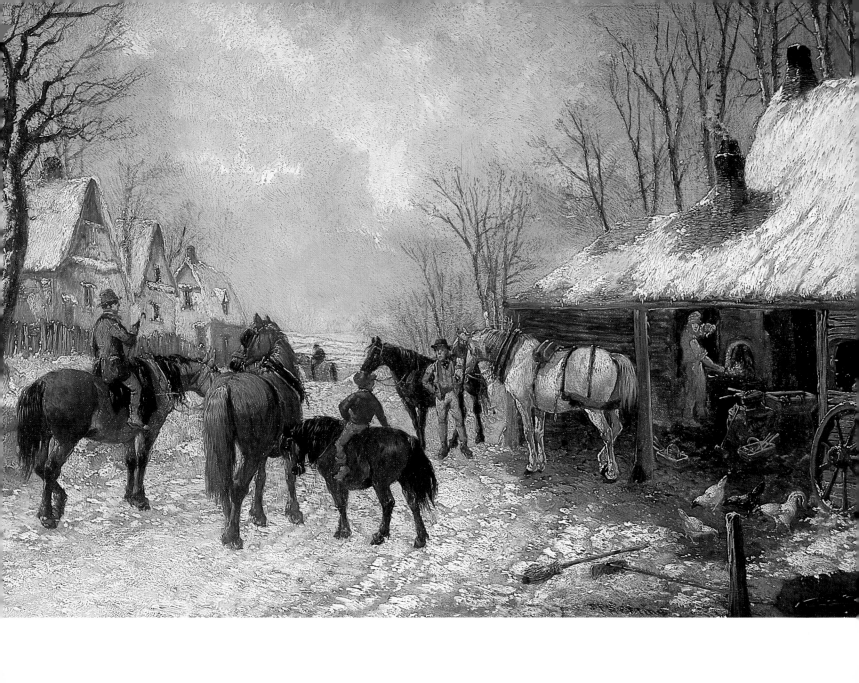

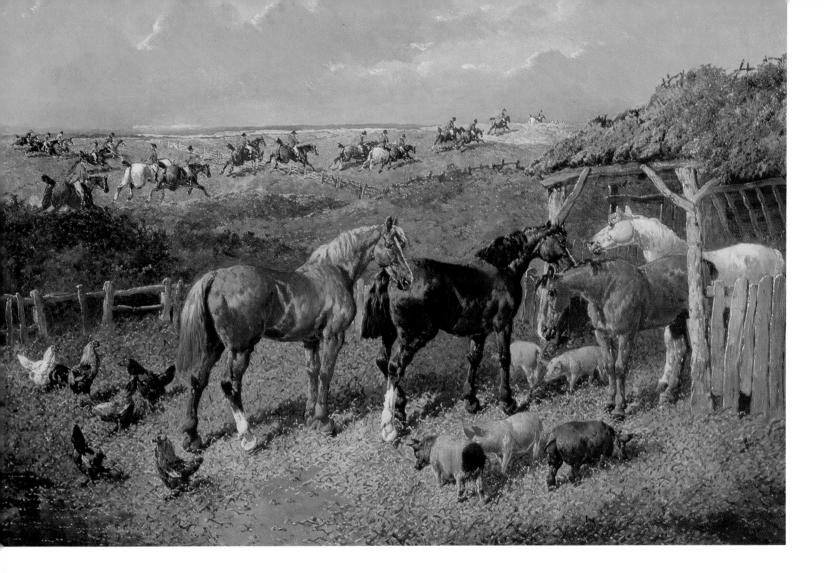

JOHN FREDERICK HERRING, JR.

Above: ***Hunters, Poultry and Pigs Near a Barn, with a Hunt Beyond***
Oil on canvas, 15¾″ x 23¾″. Signed. One of a pair.

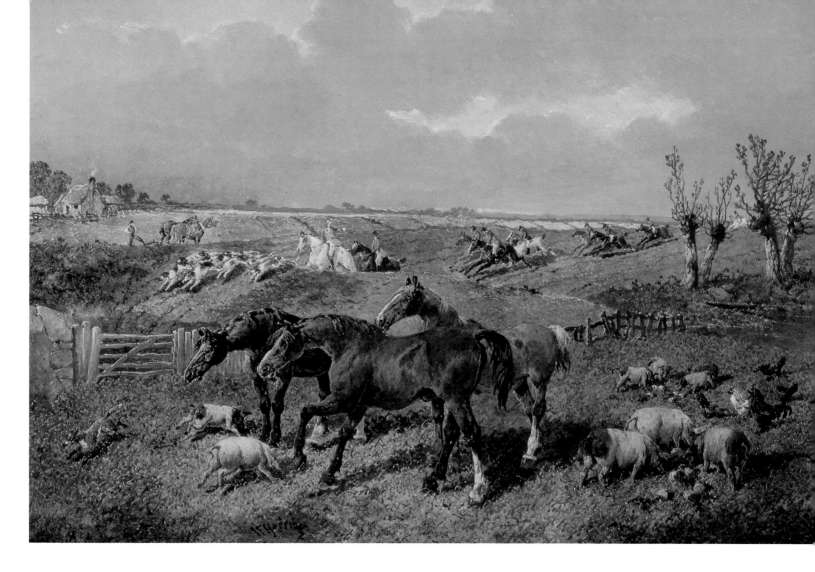

JOHN FREDERICK HERRING, JR.
Above: **_Hunters, Poultry and Pigs in a Field_**
Oil on canvas, 15¾″ x 23¾″. Signed. One of a pair.

49

JOHN FREDERICK HERRING, JR.
Right: **Return of the Plough Team**
Oil on canvas, 27½″ x 35½″. Signed.

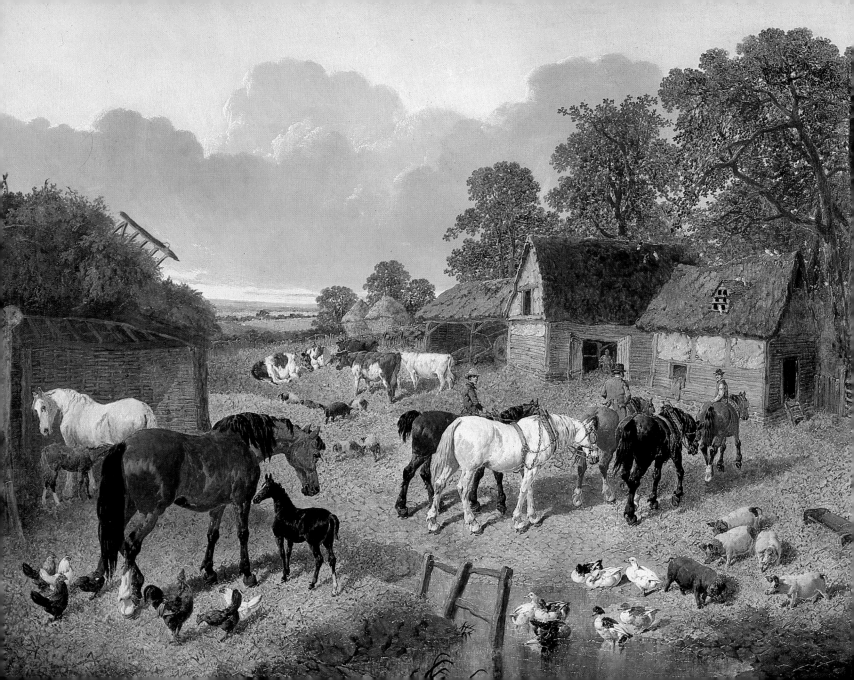

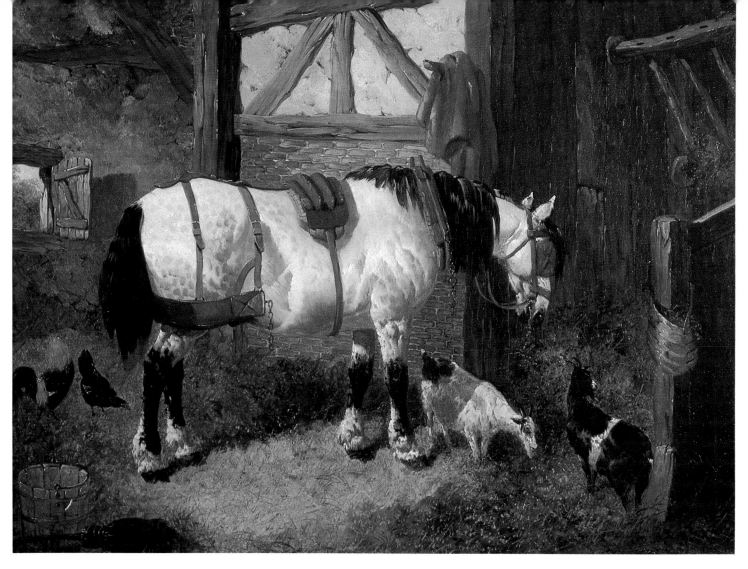

JOHN FREDERICK HERRING, JR.
Above: *Harnassed Gray in a Barn*
Oil on canvas, 15″ x 20″. Signed.

52

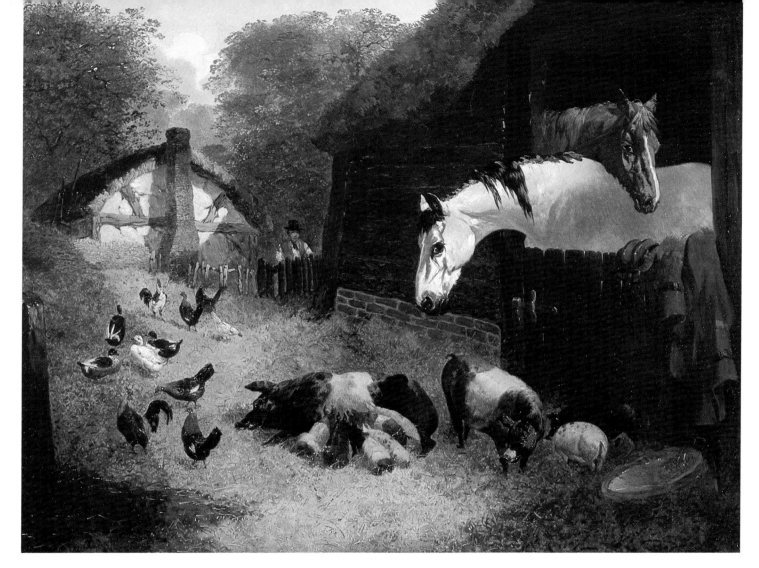

JOHN FREDERICK HERRING, JR.
Above: ***Horses in a Loose Box***
Oil on canvas, 15″ x 20″. Signed.

JOHN FREDERICK HERRING, JR.
Top Right: **Horses in a Farmyard**
Oil on canvas, 21½" x 35½".

**HARRY HALL
(ACTIVE
1838-1886)**

Harry Hall was a Newmarket artist specializing in studies of racehorses, hunters and portraits of notable sporting figures. Hall achieved great popularity, with over 60 of his portraits of racehorses being engraved and 114 plates appearing in The Sporting Magazine. However, for one so prolific, surprisingly little is known about his life. Harry Hall exhibited 11 works at the Royal Academy, 17 works at the British Institution, and 26 works at the Society of British Artists at Suffolk Street.

Bottom Right: **'Robin Rhone', a Roan Racehorse in a Stable**
Oil on canvas, 22" x 30". Signed, inscribed and dated 1864.

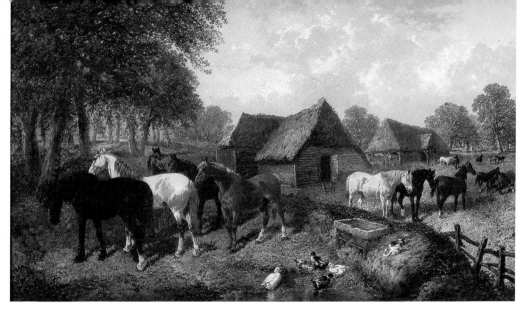

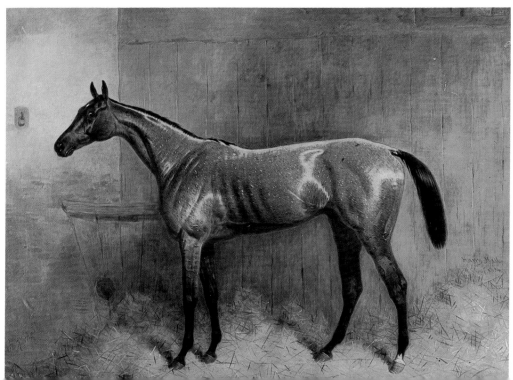

WILLIAM A. SEXTIE (ACTIVE 1848-1887)

William Sextie lived at Marlborough and specialized in painting the portraits of racehorses, their owners, trainers and jockeys. This he did with such a meticulously correct manner that his work is of great historical value to bloodstock enthusiasts and historians of the turf.

Right: *'Geheimniss', with Tom Cannon Up*
Oil on canvas, 36″ x 46″. Signed and dated 1882.

'Geheimniss' was a handsome bay filly by 'Rosicrucian' out of 'Nameless'. Owned by Lord Stamford, who bought her from Tom Cannon, she was trained by John Porter and won all her seven races as a two-year-old in a canter. In 1882 she was an odds-on favorite for the Oaks which, with Tom Cannon up, she won with ease. She was a hot favorite for the St. Leger, but did not really stay the distance. She was second to 'Dutch Oven' ridden by Fred Archer. In 1884, she won the Queen's Stand Plate at Ascot and the Stockbridge Gold Cup. After a successful career at stud, she was exported to Germany in 1893.

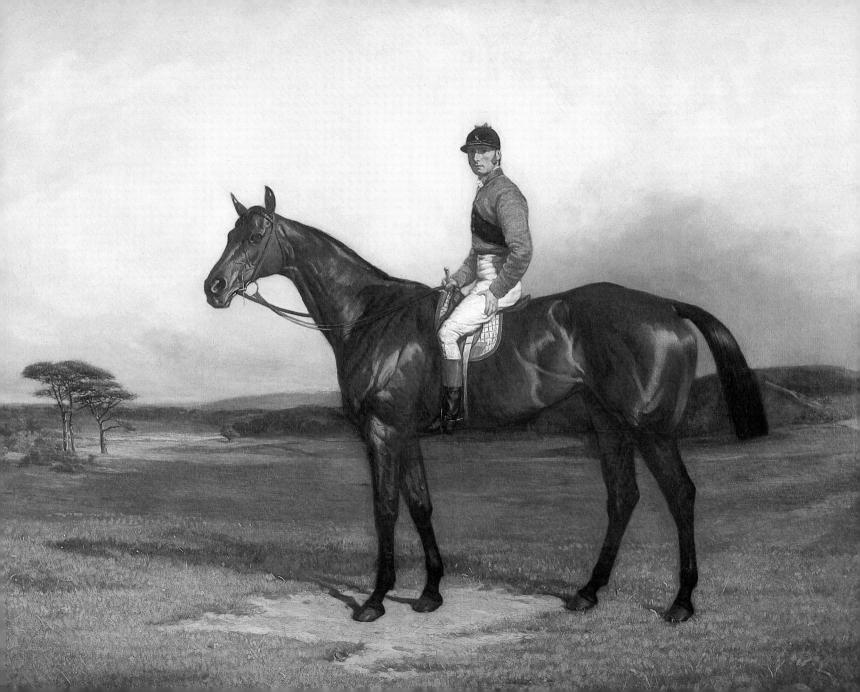

WILLIAM A. SEXTIE
Right: ***Fred Archer on 'Cherry'***
Oil on canvas, 27¼″ x 35″. Signed and dated 1884.
Literature: Theodore Cook, "The History of the English Turf", p. 536 (illus.) and p. 631.

'Cherry', a chestnut mare, was foaled in 1881 by 'Stirling' out of 'Cherry Duchess'. She won four races to a total value of 5,361 pounds. At stud she bred 'Cereza', winner of five races worth 6,429 pounds. She was owned by Mr. Broderick Clouete and was trained by John Porter.

Frederick James Archer (1857-1886) captured the public imagination as no other jockey had ever done before. As well as being a natural horseman, his employment of tactics and knowledge of horses made him a jockey of genius and brought him phenomenal success. He was abstemious and self-disciplined in his private life and made shrewd investment of most of the huge sums paid to him. This ability to look after money gained him a reputation for meanness in which he took a perverse satisfaction, and earned himself the nickname of "The Tinman" ("tin" being Victorian slang for money). Archer was unusually tall for a jockey and he used his long legs to squeeze the last ounce of energy out of his mounts. He rode a very strong finish and was unsparing in the use of his whip. Due to his height he always had to waste rigorously to lose weight. In the autumn of 1886, at the end of a cold afternoon, he was running a fever. In spite of his deteriorating health, he continued to ride until he was forced to take to his bed. A few days later he shot himself in a fit of delirium, using a pistol which he kept on his bedside table as a precaution against burglars.

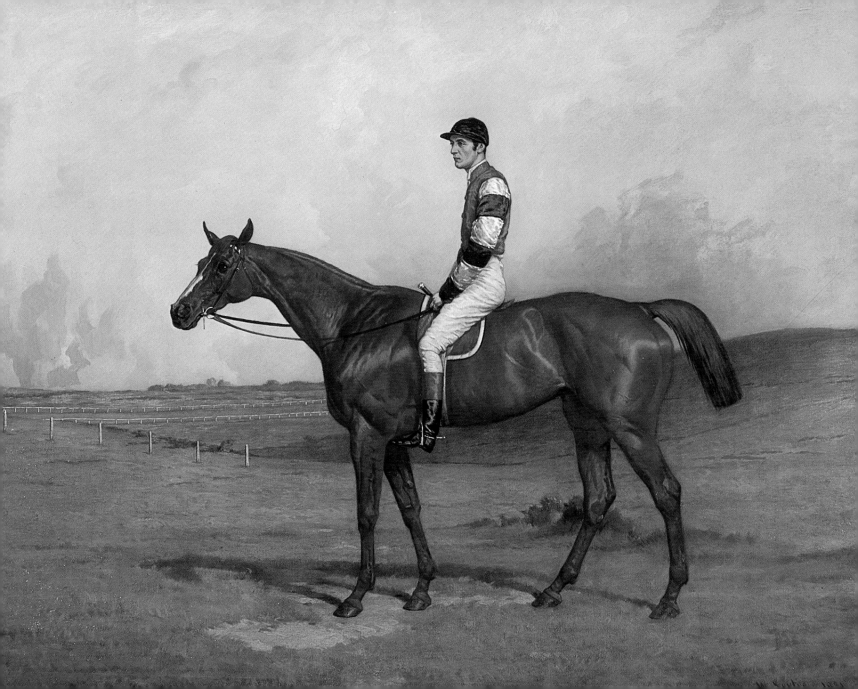

WILLIAM A. SEXTIE
Right: **Tom Cannon and His Sons on Danebury Gallops**
Oil on canvas, 29½" x 44½". Signed.

Thomas Cannon (1846-1917) was a most accomplished and graceful horseman as well as a skillful jockey. He had the lightest of hands and it was generally agreed that he was without equal as a rider of two-year-olds. Fillies, too, responded to his gentle handling more readily than they did to the harsher treatment they received from some of his contemporaries. Riding well back in the saddle in the classic style of the time, he loathed making the running, preferring to hold his mount in check for a late challenge that was usually timed to perfection. His sons, maintaining the family tradition, went on to become riders and trainers of the highest class. This tradition has carried through to the present day. Tom Cannon was the great-grandfather of one of today's best known jockeys, Lester Pigott.

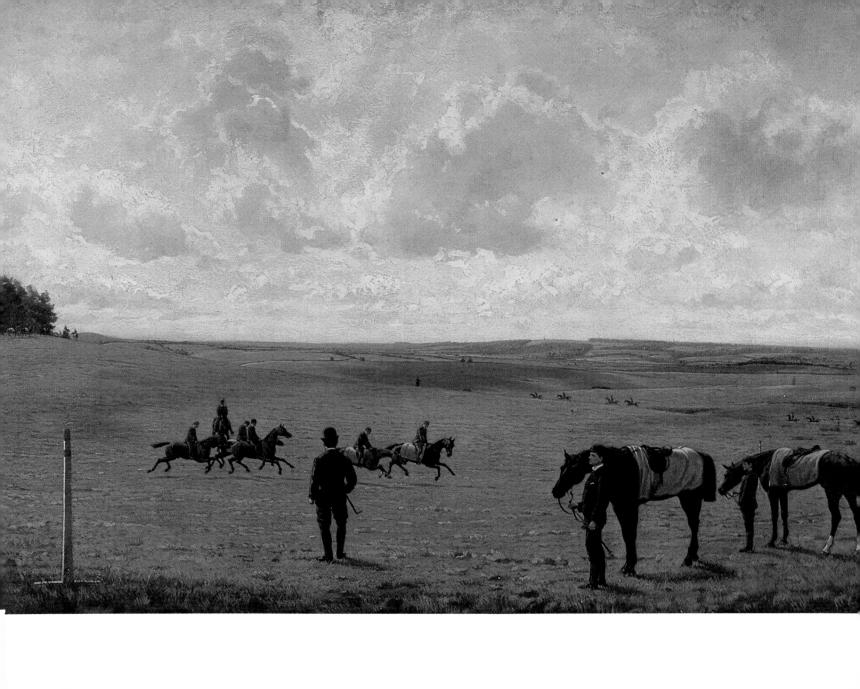

ALFRED WHEELER (1852-1932)

Alfred Wheeler, born near Bath in 1852, was the son of the sporting painter John Arnold Wheeler (1821-1877). Like his father, Alfred Wheeler specialized in painting subjects of a sporting nature.

Right: **'Flying Fox'**
Oil on canvas, 17″ x 13½″. Signed and inscribed.

The Duke of Westminster's 'Flying Fox', a bay colt by 'Orme' out of 'Vampire', was trained by John Porter. Despite an ineffectual season as a two-year-old, 'Flying Fox' was a hot favorite for the Two Thousand Guineas the following season. He duly obliged his followers by winning the race from 'Caiman'. In the Derby, ridden by Tom Cannon's son, Mornington, he started favorite at 5/2 on, and won comfortably from 'Damocles'. 'Flying Fox' went on to win several more races that season, including the St. Leger. However, because of his uncertain temperament, it was decided not to race him as a four-year-old. It is probable that the jockey portrayed in this picture of 'Flying Fox' is Mornington Cannon, who rode him to his three Classic successes in 1899.

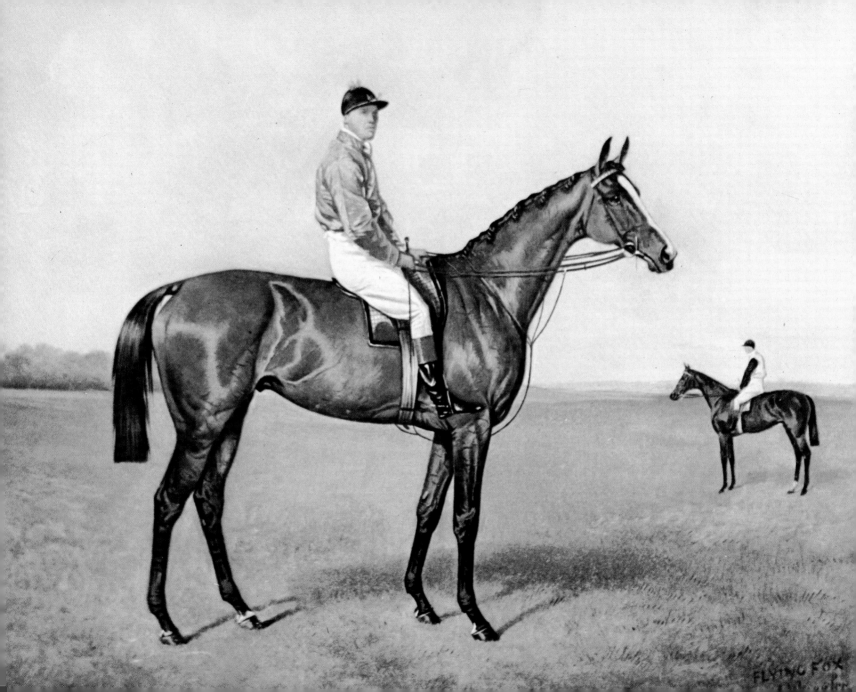

FLYING FOX

RICHARD BARRETT DAVIS, R.B.A. (1782-1854)

Richard Barrett Davis was born in 1782 and studied under Evans of Eton, Sir William Beechey, and in the schools of the Royal Academy (where he first exhibited in 1802). Davis joined the Society of British Artists in 1829. He was Huntsman to the Royal Harriers, and was appointed Animal Painter to King William IV in 1831. Davis exhibited 70 works at the Royal Academy, 57 works at the British Institution, and 141 works at the Society of British Artists in Suffolk Street.

Right: *'Eaton', A Bay Racehorse, Owned by Lord Grosvenor, with a Groom in a Wooded Landscape*
Oil on canvas, 23½″ x 29½″. Signed and dated 1821.
Provenance: Stoke Park, Stoke Poges, Bucks.

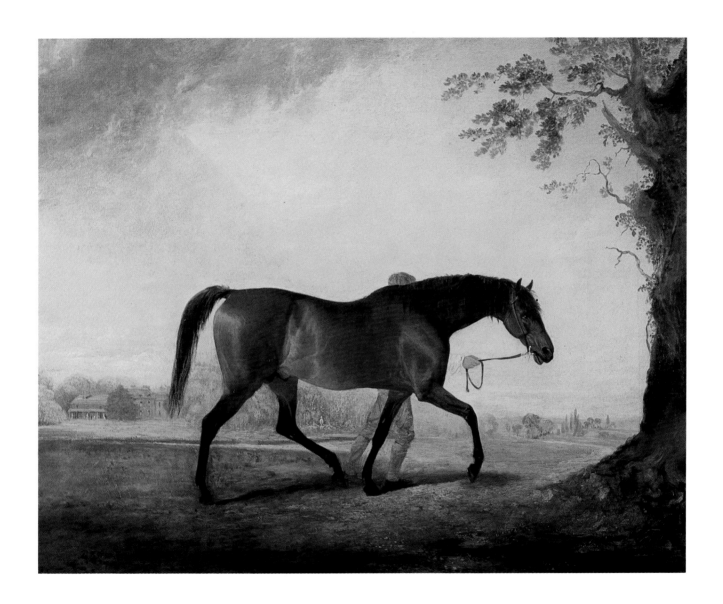

65

**CAPTAIN
ADRIAN JONES
(1845-1938)**

Adrian Jones was an army veterinary surgeon who, after retiring from the army, studied art under Charles Bell Birch, A.R.A. Jones exhibited sculpture and paintings in London from 1884.

Right: *A Bay Hunter in a Stable*
Oil on canvas, 25″ x 30″. Signed and dated 1891.

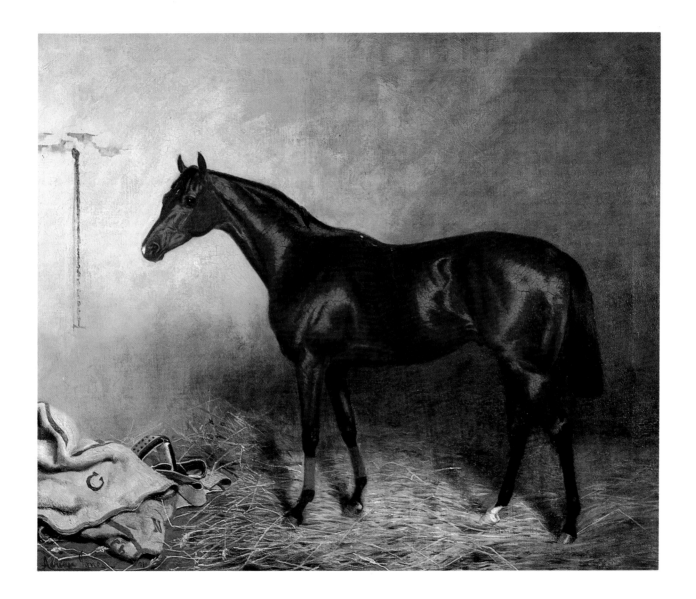

GEORGE WRIGHT (1856-1942)

George Wright worked in Leeds, Oxford and Rugby, painting hunting, coaching and other sporting scenes and, more rarely, portraits of horses. In his hunt scenes, Wright was a master at portraying the actual paces of a horse, whether walking or galloping. Thus he imbued his painting with a feeling of movement and realism that is lacking in many of his contemporaries. Wright frequently exhibited at the Royal Academy.

Literature: Christopher Wood, "The Dictionary of Victorian Painters", 2nd Edition, 1978, Illustrated.

Right: ***A Huntsman with His Grey Hunter and Hounds, Outside a Blacksmith's Shop***
Oil on canvas, 16" x 20". Signed and dated 1887.

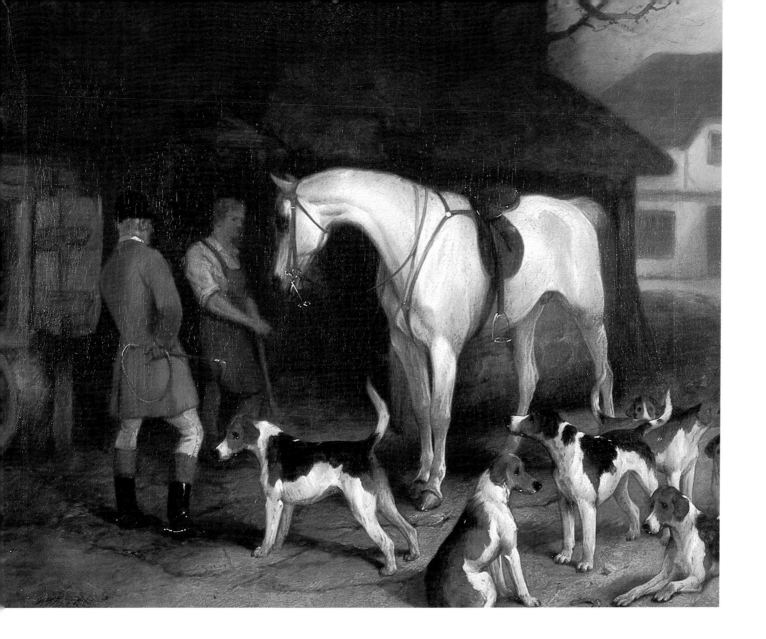

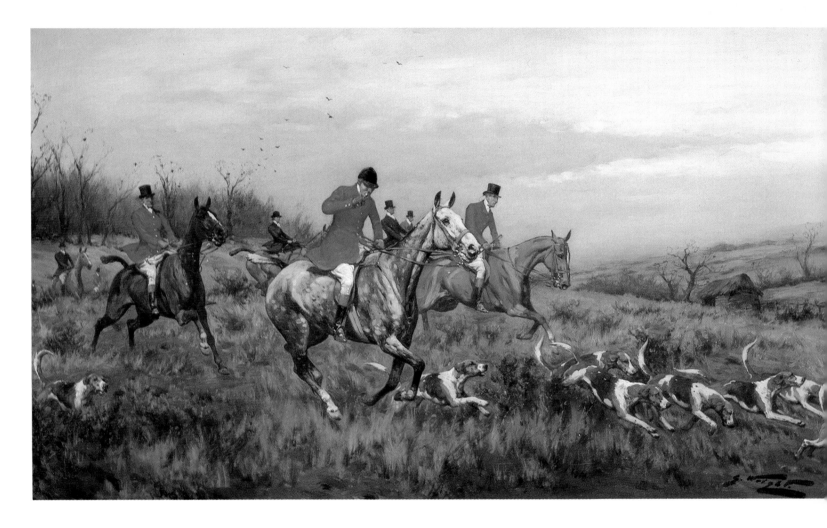

GEORGE WRIGHT
Above: *Out of the Covert in Full Cry*
Oil on canvas, 9¾″ x 17½″. Signed.

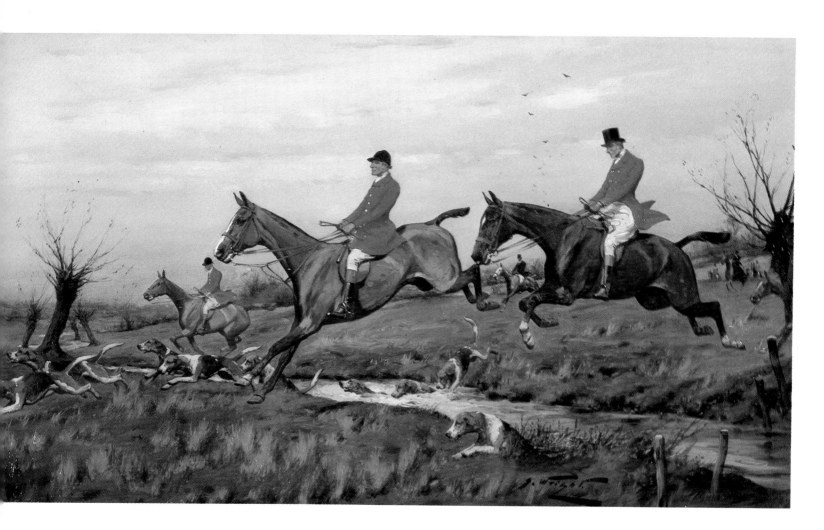

GEORGE WRIGHT
Above: ***Over the Water***
Oil on canvas, 9¾″ x 17½″. Signed.

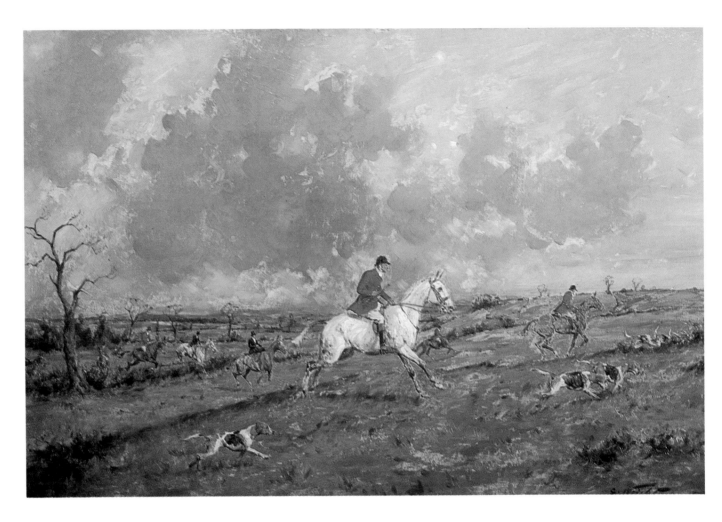

GEORGE WRIGHT
Above: ***In Full Cry***
Oil on canvas, 19½″ x 29½″. Signed and inscribed on the reverse.

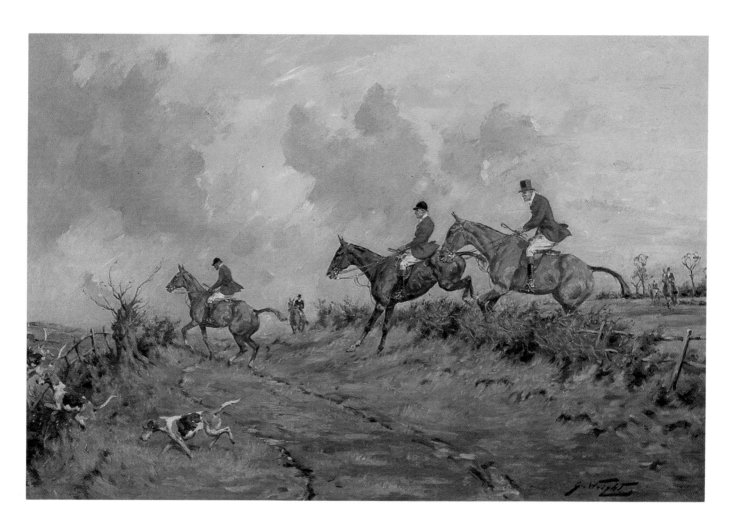

GEORGE WRIGHT
Above: ***Taking a Fence***
Oil on canvas, 15½″ x 23½″. Signed.

THOMAS BLINKS (1860-1912)

Thomas Blinks was almost entirely a sporting painter, and though he produced work of almost photographic exactitude, his hunting and steeplechasing scenes were painted with great movement and life. He is one of the best Victorian painters of foxhounds. During his lifetime, Thomas Blinks exhibited 9 works at the Royal Academy, and 4 works at the Society of British Artists in Suffolk Street.

Right: *In Full Cry*
Oil on canvas, 20" x 29½". Signed and dated '97.

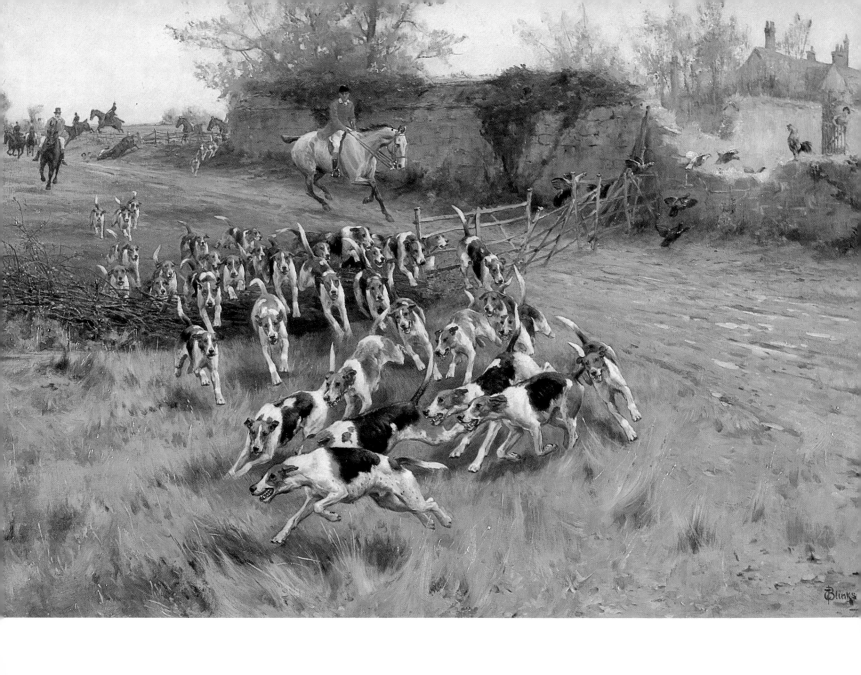

**JOHN
SANDERSON
WELLS, R.I.
(ACTIVE
1892-1938)**

John Sanderson Wells was a painter of genre who also produced accurate coaching and hunting scenes. He exhibited at the Royal Academy between 1895 and 1914.

Right: *Early Morning*
Oil on canvas, 15½″ x 23½″. Signed.

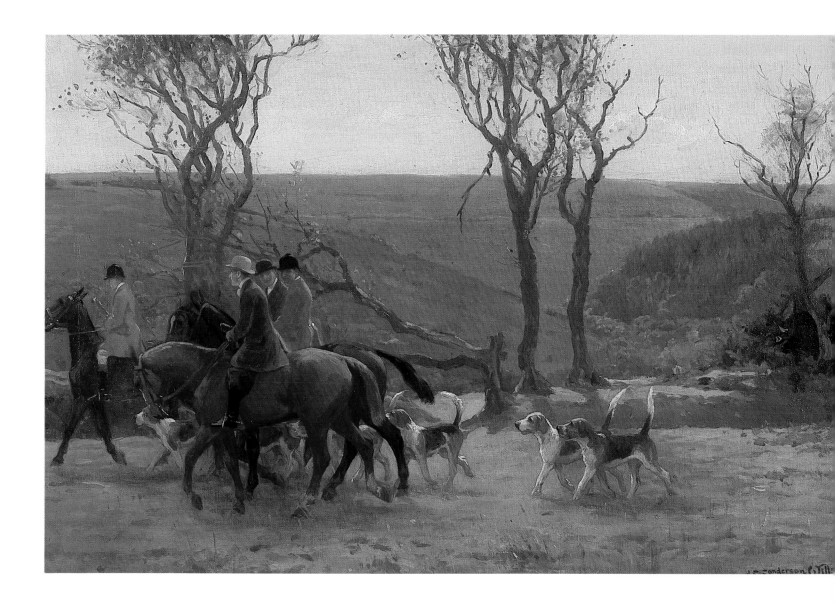

SAMUEL EDMUND WALLER (1850-1903)

Samuel Edward Waller studied at Gloucester School of Art under John Kemp. He worked for his father (who was an architect) as well as on the family farm, where he made many studies of animals. Waller was a painter of animals and genre. He exhibited 26 works at the Royal Academy and 2 at the Society of British Artists in Suffolk Street.

Right: *The Huntsman's Courtship*
Oil on canvas, 47¼″ x 65½″. Signed and dated 1899.
Provenance: Sir Thomas Pilkington, Bt.
Exhibited: Royal Academy, 1899, No. 366

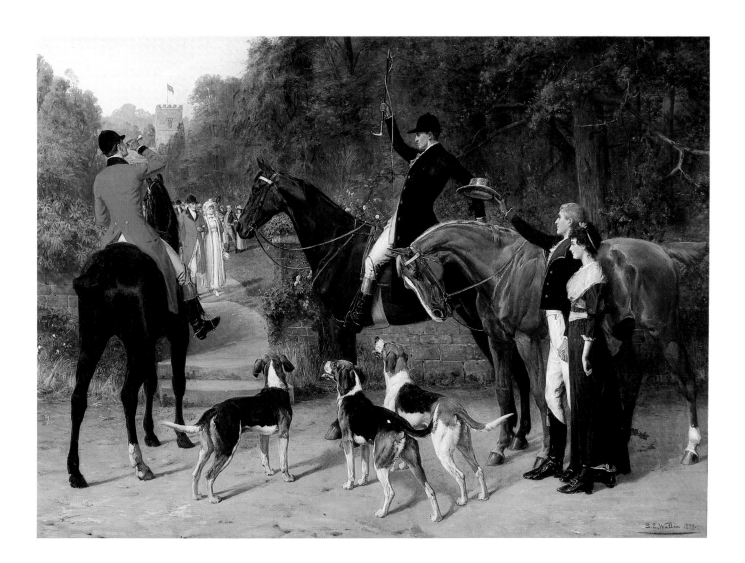

E. B. HERBERTE
(ACTIVE
1860-1893)

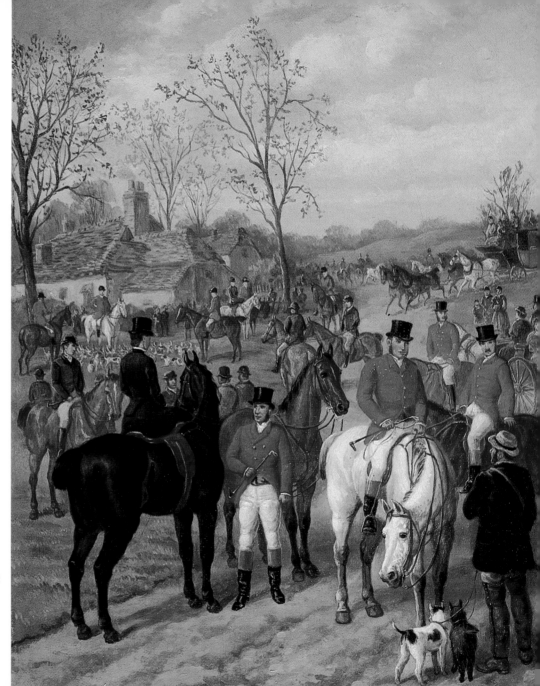

Right: ***The Meet***
Oil on canvas, 17½" x 13½".
Signed and dated 1884. First in a set of four.

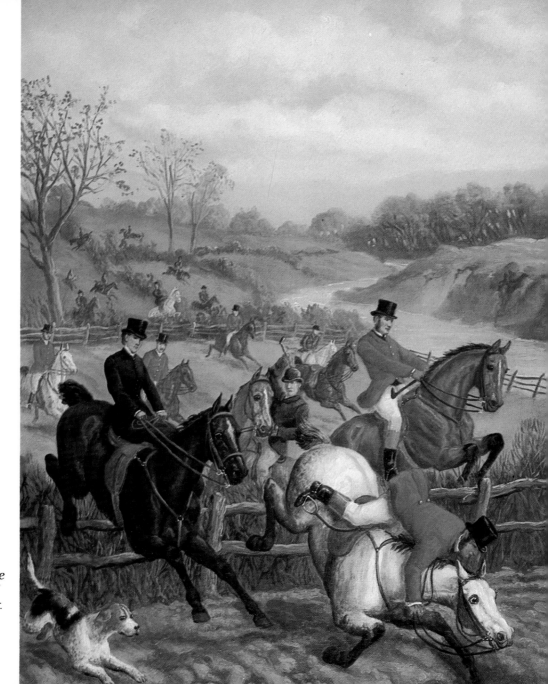

Right: ***Taking a Fence***
Oil on canvas, 17½" x 13½"
Signed and dated 1884. Second in a set of four.

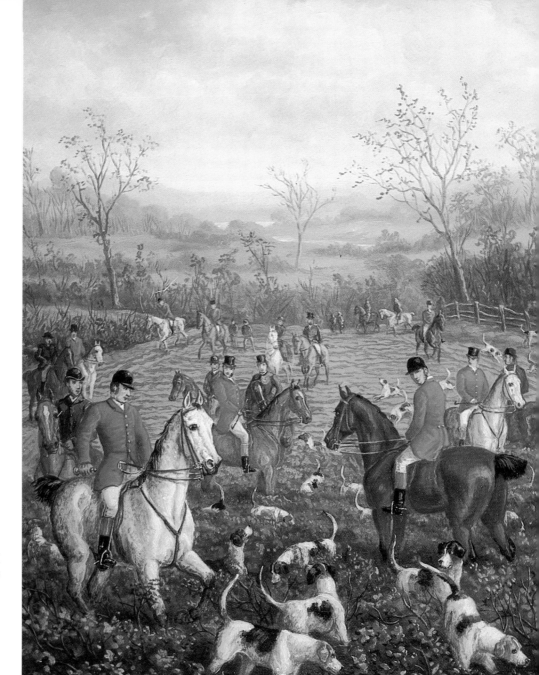

E. B. HERBERTE
Right: ***The Draw***
Oil on canvas, 17½" x 13½".
Signed and dated 1884. Third in a set of four.

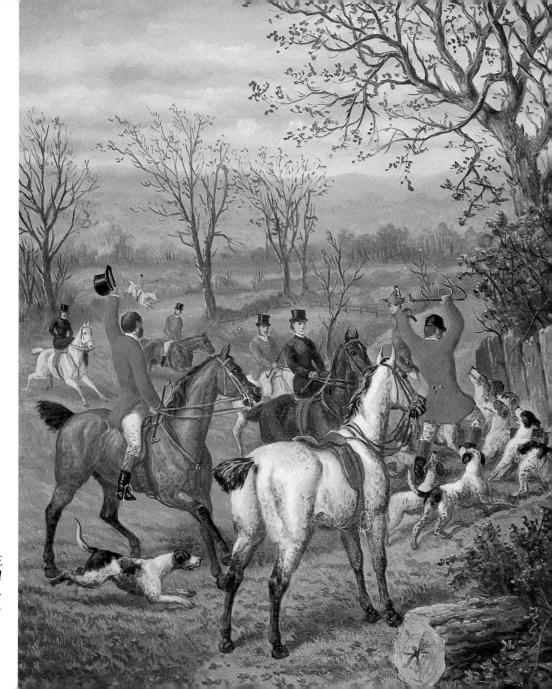

E. B. HERBERTE
Right: *The Kill*
Oil on canvas, 17½" x 13½".
Signed and dated 1884. Fourth in a set of four.

John Charles Maggs was the leading painter of the English coaching scene. Maggs lived all his life in Bath where he ran a successful painting school. He possessed one of the best and most comprehensive libraries on coaching and driving subjects which no doubt contributed to the accuracy and authenticity of his paintings.

His works (which were accomplished just as the old, traditional coaches were fast being replaced by the steam engine) were widely exhibited (though never in London!) and much sought after. His many aristocratic patrons, who wished to possess mementos of the romantic age of coaching, included Queen Victoria, the Duke of Beaufort, and the Earl of Abergavenny.

Right: ***A Busy Coaching Scene in a Snow Covered Street in Bristol***
Oil on canvas, 33½" x 51½". Signed and dated 1873.

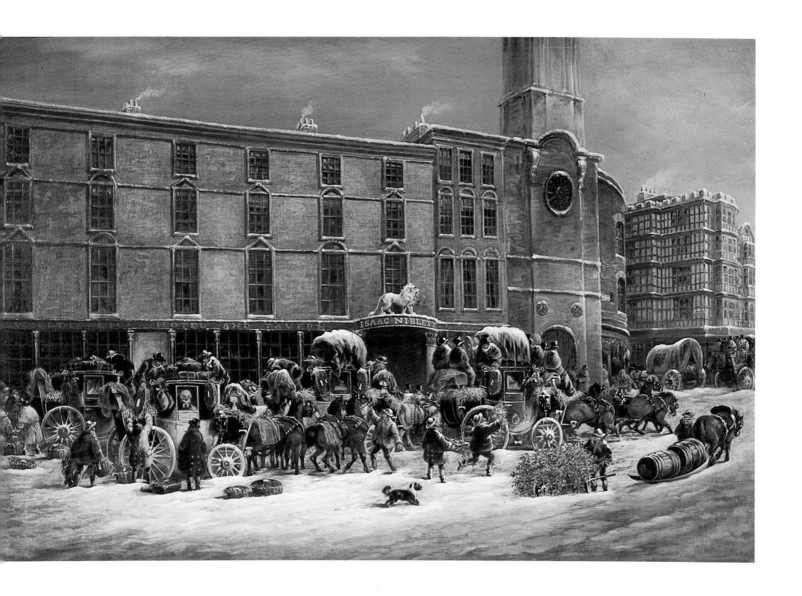

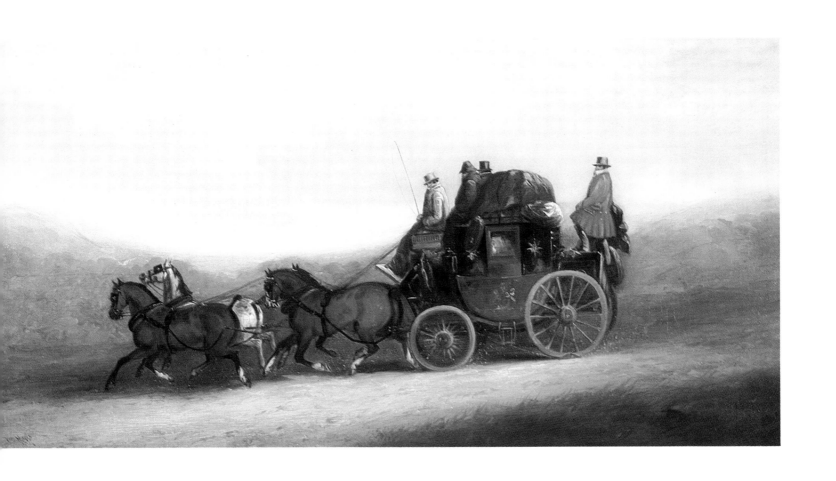

JOHN CHARLES MAGGS
Above: ***London-Birmingham Run: Leaving London Fully Loaded***
Oil on canvas, 12¾″ x 26″. Signed and dated 1874.

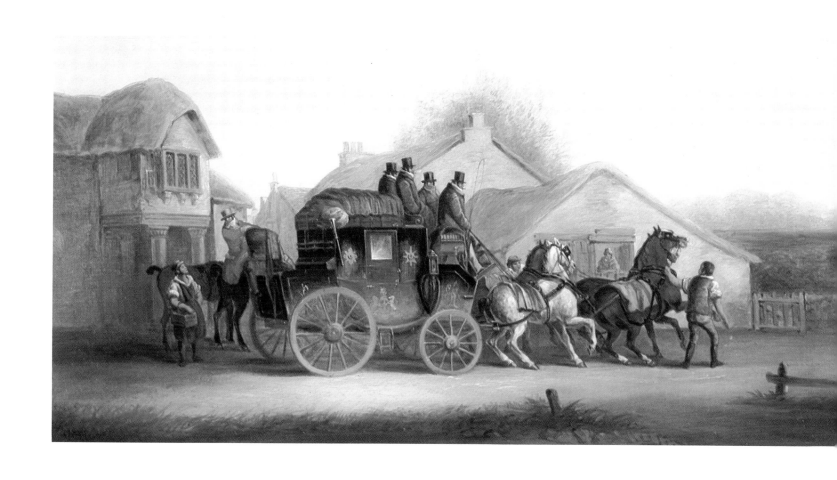

JOHN CHARLES MAGGS
Above: ***London-Birmingham Run: Overnight Stop in Luton***
Oil on canvas, 12¾″ x 26″. Signed and dated 1874.

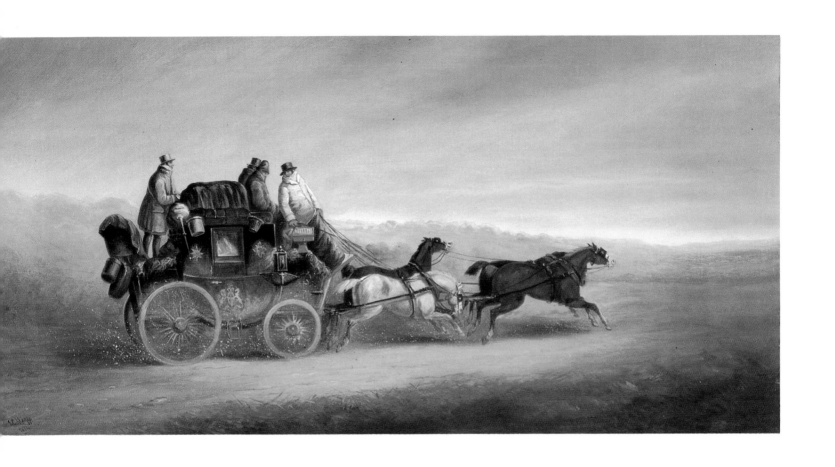

JOHN CHARLES MAGGS
Above: ***London-Birmingham Run: Two Days Out of London***
Oil on canvas, 12¾" x 26". Signed and dated 1874.

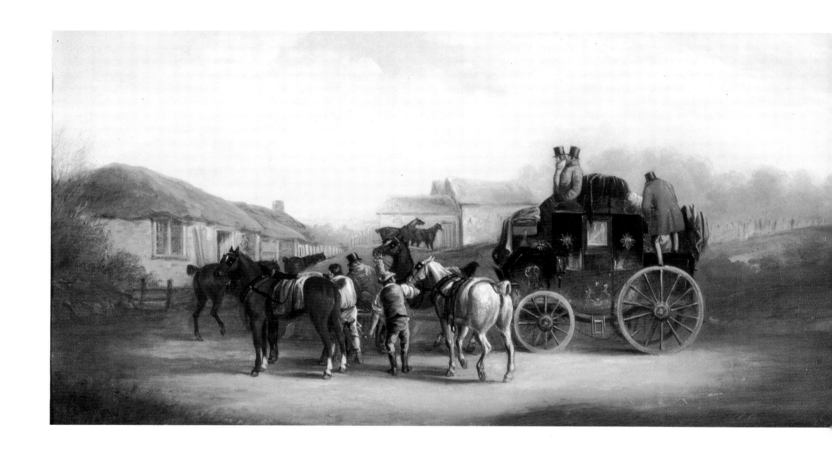

JOHN CHARLES MAGGS
Above: ***London-Birmingham Run: Changing Horses in Northampton***
Oil on canvas, 12¾″ x 26″. Signed and dated 1874.

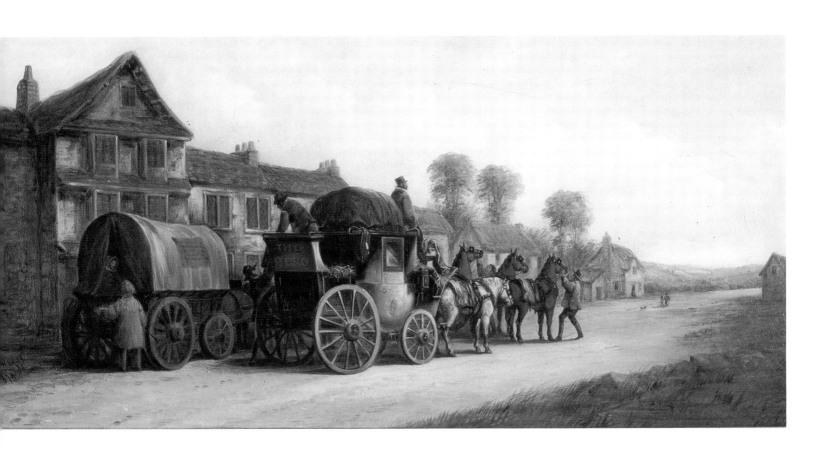

JOHN CHARLES MAGGS
Above: ***London and Bristol Royal Mail***
Oil on canvas, 13″ x 26″. Signed and dated 1875.

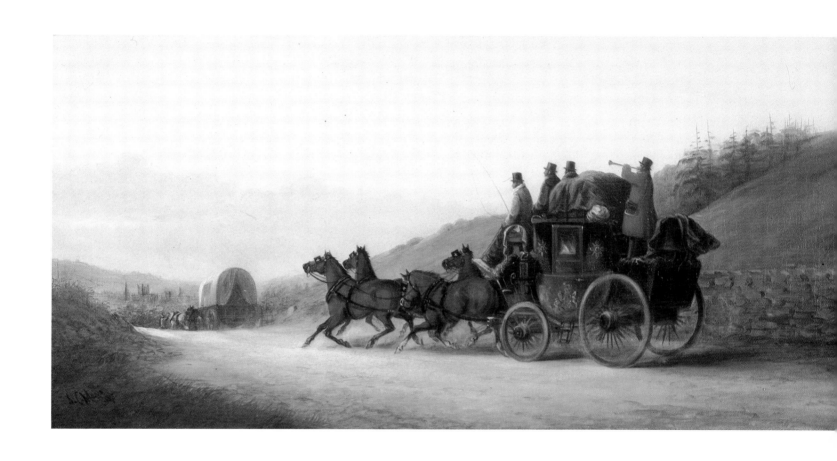

JOHN CHARLES MAGGS
Above: ***The Hero: Bristol, Bath and London Coach***
Oil on canvas, 13″ x 26″. Signed and dated 1875.

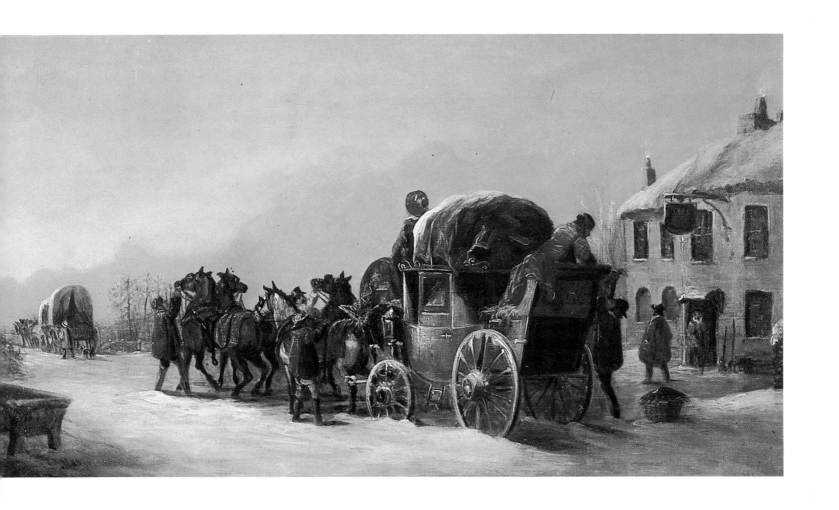

JOHN CHARLES MAGGS
Above: ***A Coach and Four Outside the George Inn in Winter***
Oil on canvas, 13½″ x 25½″. Signed, inscribed Bath and indistinctly dated 187?.

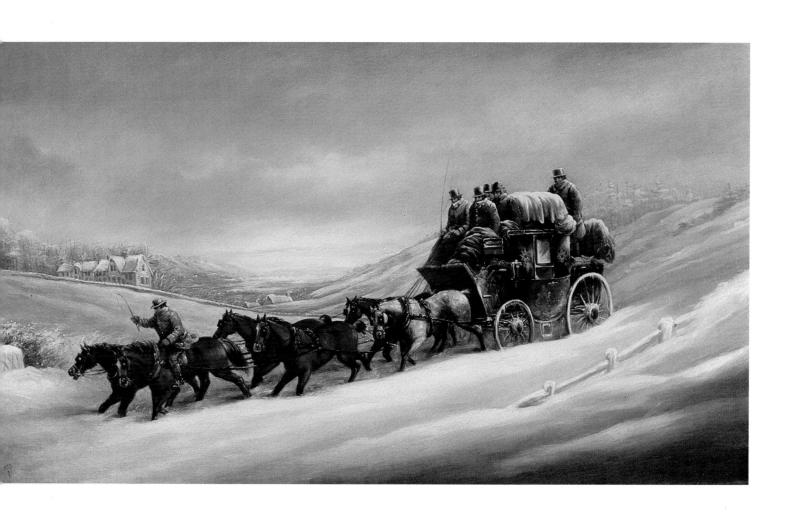

JOHN CHARLES MAGGS
Above: ***A Coaching Scene in a Winter Landscape***
Oil on canvas, 17½″ x 31½″. Signed and dated Bath 1873.

JOHN CHARLES MAGGS
Right: ***The Hero: The Oxford to London Mail Coach with Huntsmen on a Country Road***
Oil on canvas, 13½″ x 26½″. Signed and dated Bath 1880.

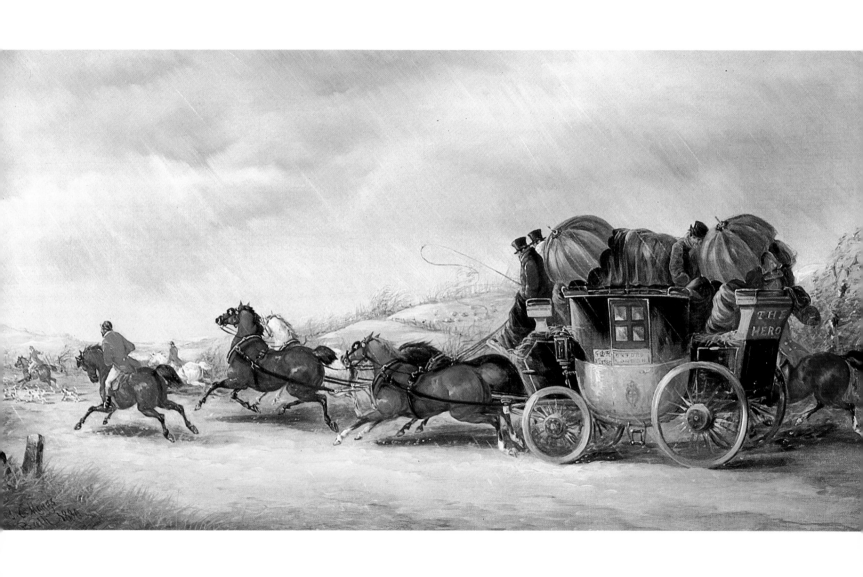

HENRY ALKEN, JUNIOR (1810-1894)

Henry Alken, Junior, who is also known as Samuel Henry Gordon Alken, was the elder son of Henry Thomas Alken (1785-1851), known as Henry Alken, Senior. Alken Junior was born in Ipswich in 1810 and studied under his father, of whom he was a close disciple. He has often been described as purely an imitator of his father's work. This is understandable because he not only followed his father's style, but he also signed his work "H. Alken", as did his father. In fact, Alken Junior had considerable talent as a sporting painter in his own right—though lacking a little of the fine delicacy of touch which marked his father's work. Henry Alken Junior died in London in 1894.

Right: ***On Shank's Pony***
Oil on canvas, 13½″ x 17½″.

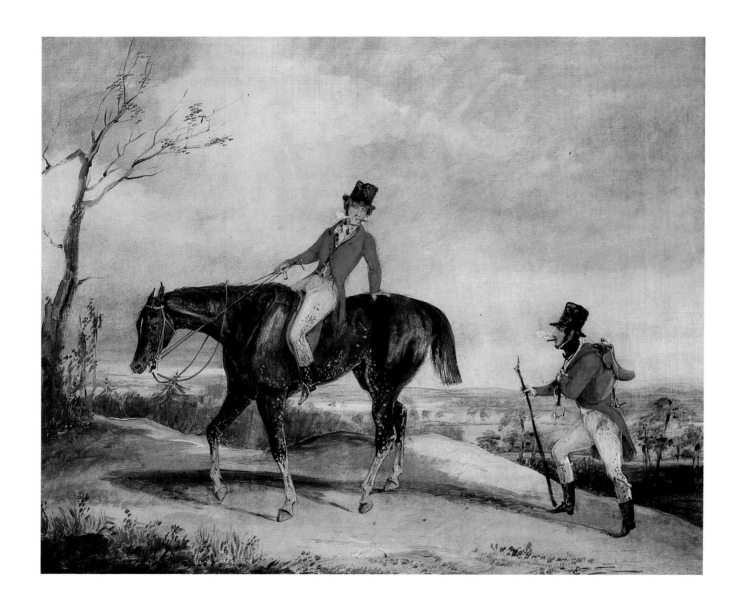

97

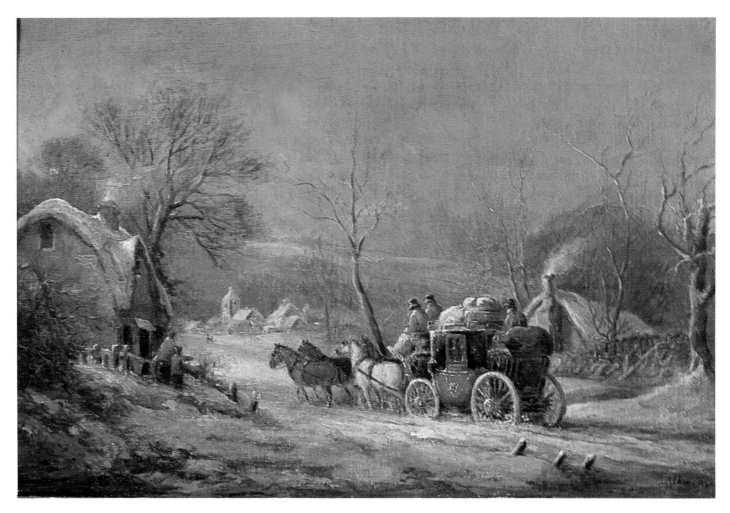

HENRY ALKEN, JR.
Above: ***A Mail Coach Passing the Village in Winter***
Oil on canvas, 16″ x 24″. Signed.

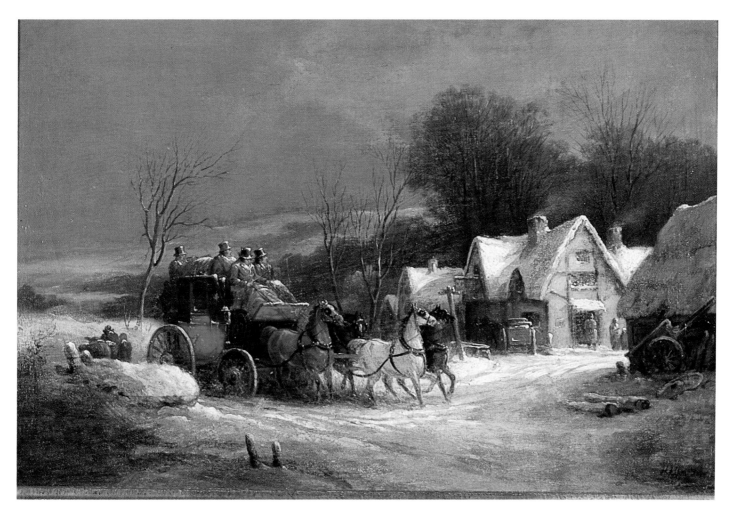

HENRY ALKEN, JR.
Above: *A Mail Coach Passing the Inn in Winter*
Oil on canvas, 16″ x 24″. Signed.

JOHN FERNELEY, JUNIOR (ACTIVE 1815-1862)

John Ferneley Junior was the eldest son of the Melton Mowbray sporting painter, John Ferneley Senior (1782-1860). Very little is known of Ferneley Junior's life, except that he lived and worked in Manchester, York and eventually died in Leeds. His work is often confused with his father's and they undoubtably collaborated on many pictures. One distinguishing characteristic is that John Ferneley Junior usually signed his work "John Ferneley" and his father signed his "J. Ferneley."

Right: *A Saddled Cob and Dog*
Oil on panel, 17½″ x 23½″. Signed and dated York 1839.

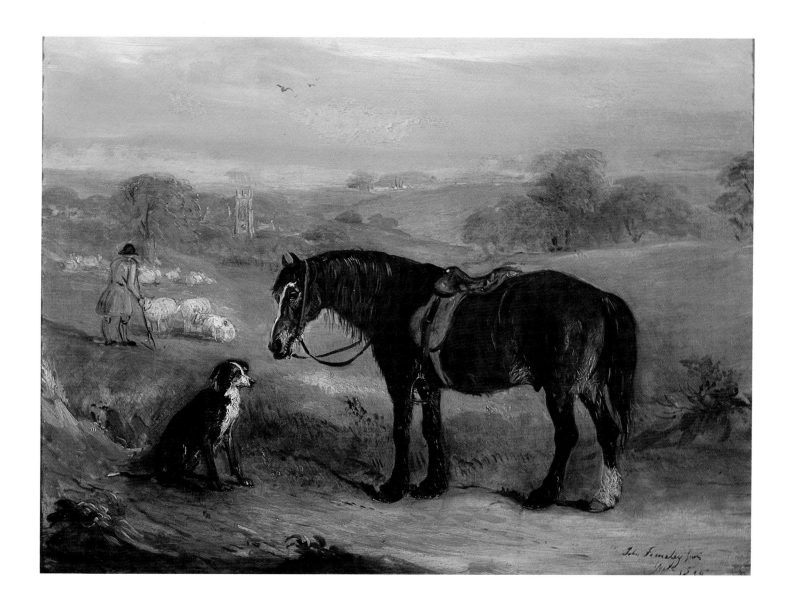

JAMES WILLIAM COLE (ACTIVE 1849-1882)

James William Cole was a London painter of animals and domestic scenes. He exhibited 11 works at the Royal Academy, 24 works at the British Institution, and 28 works at Suffolk Street.

Right: ***Meet of the Limerick Foxhounds — A Bye Day***
Oil on canvas, 38½″ x 59″. Signed and dated 1853.
Exhibited: The Royal Academy, 1853, NO. 377
The names of the principal figures in this painting
are inscribed on the reverse: "...with Mr. and Mrs. Green of Green Mount,
Mr. Henry, The Rev. Mr. Coker and Mr. Foster"

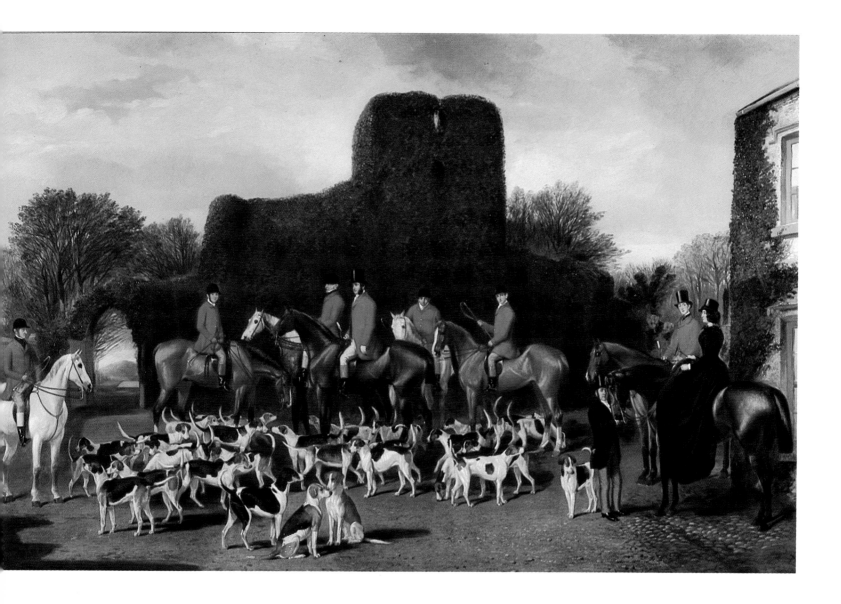

THOMAS SMYTHE (1825-1907)

Thomas Smythe was an Ipswich painter who was the brother of Edward Robert Smythe. They both painted landscapes and coastal scenes with animals and figures. Thomas Smythe did not exhibit in London.

Right: *The Mid-Day Rest*
Oil on canvas, 17½″ x 23½″. Signed.

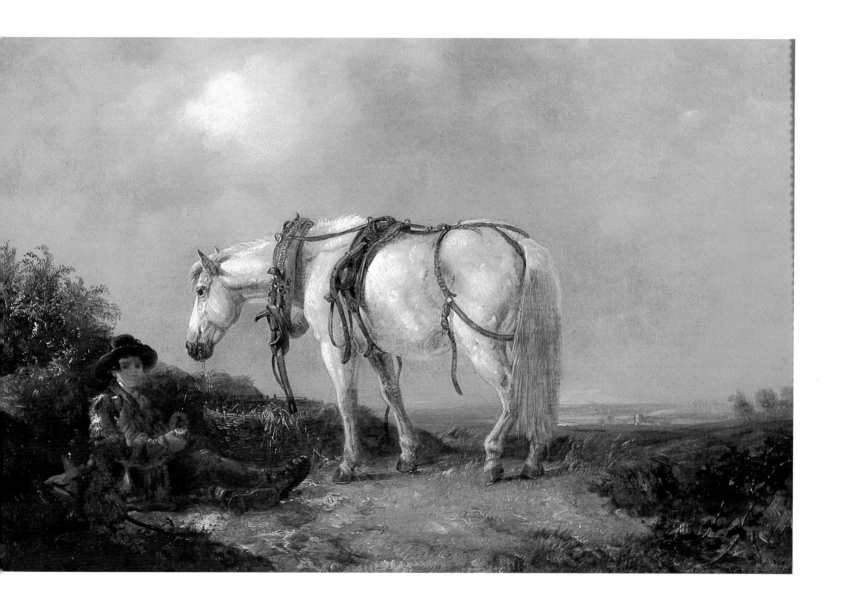

HEYWOOD HARDY, A.R.W.S. (1843-1933)

Heywood Hardy was a painter and watercolorist of animals, sporting subjects and genre. During his lifetime he exhibited 31 works at the Royal Academy, 9 works at the British Institution, and 16 works at the Society of British Artists in Suffolk Street.

Right: *A Visit to the Kennels*
Oil on canvas, 40″ x 28″. Signed.

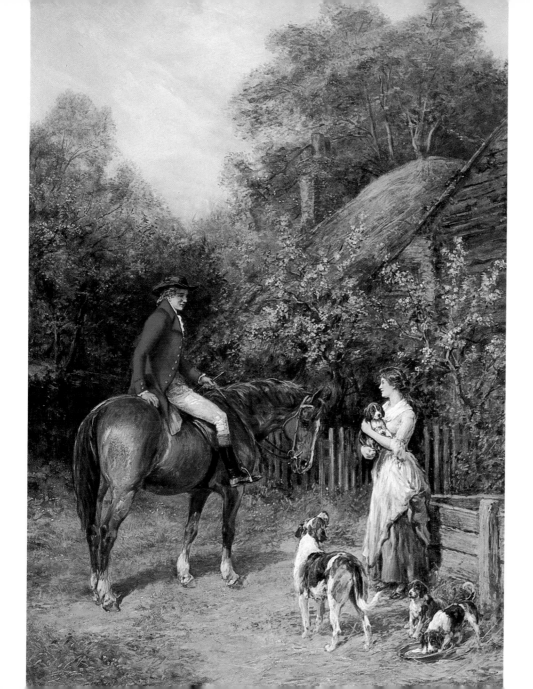

107

**JEAN-MAXIME
CLAUDE
(1824-1904)**

Jean-Maxime Claude was born in Paris in 1824. He specialized in painting hunt scenes and landscapes. His work was first presented at the Paris Salon in 1861. He was also decorated with the Legion d'Honneur. This delightful painting of hounds at rest by the French artist, Claude, has been included in what is predominantly a collection of work by English sporting painters because, apart from its obvious charm, the hounds almost certainly came from English stock. It was Louis XV who first acquired a taste for English hounds, which were faster than his Norman hounds though more expensive. The French packs needed speed, for in France they hunt the stag and not the fox. Even today, English foxhounds are regularly imported to strengthen French packs of staghounds.

Right: ***Hounds in a Landscape***
Oil on canvas, 15½″ x 45″. Signed and dated 1883.

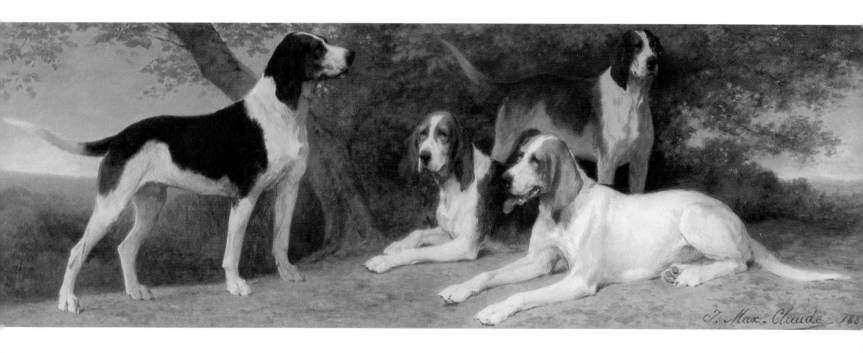

JOHN NOST SARTORIUS (1759-1828)

John Nost Sartorius was the son of the sporting painter, Francis Sartorius (1734-1804) and the grandson of another sporting artist, John Sartorius. The early and very strong tradition of English sporting painting, rather patronizingly described as the primitive style, is well represented by the Sartorius family. What they all provided for an exacting and knowledgeable (though not the most sophisticated) clientele was simplicity of composition combined with accuracy…in short, a countryman's art. A great many of John Nost Sartorius' paintings and drawings were engraved. He exhibited his works at the Royal Academy from 1778 to 1824.

Right: *The View Halloo*
Oil on canvas, 14″ x 17″. Signed.

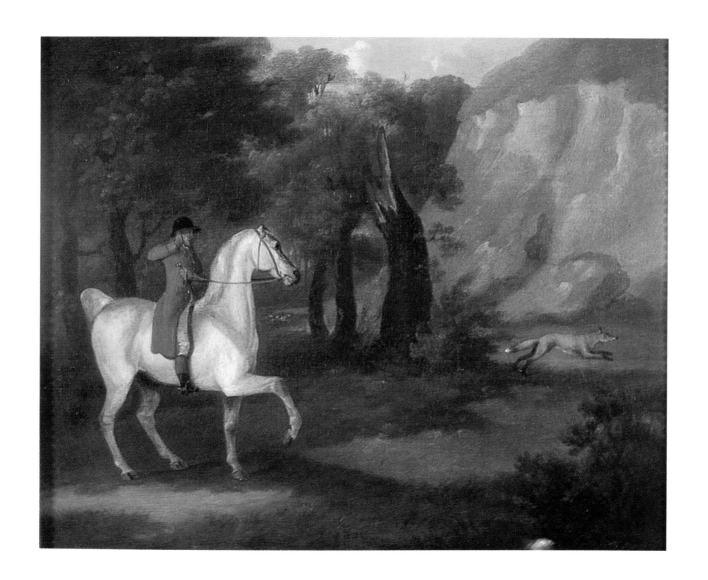

SELECT BIBLIOGRAPHY

COOMBS, DAVID: *Sport and the Countryside; English Paintings, Watercolours and Prints.* (1978).
DARWIN, BERNARD: *John Gully and His Times* (1935).
DENT, ANTHONY: *Animals in Art.* (1976).
LONGRIGG, ROGER: *The History of Horse Racing.* (1972).
MORTIMER, ROGER: *The History of the Derby Stakes.*
MORTIMER, ROGER; ONSLOW, RICHARD; WILLETT, PETER: *Biographical Encyclopaedia of English Flat Racing.* (1978).
NOAKES, AUBREY: *Ben Marshall.* (1978).
PAVIERE, SYDNEY: *A Dictionary of British Sporting Painters.* (1965).
SPARROW, WALTER, SHAW: *A Book of Sporting Painters.* (1931).
SPARROW, WALTER, SHAW: *British Sporting Artists.* (1922).
TAYLOR, BASIL: *Animal Painting in England, from Barlow to Herring.* (1955).
TAYLOR, BASIL: *Stubbs.* (1975).
WALKER, STELLA: *Sporting Art. England 1700-1900* (1972).
WOOD, CHRISTOPHER: *A Dictionary of Victorian Painters.* (1978).
WOOD, LIEUT. COL. J. C.: *A Dictionary of British Animal Painters.* (1973).

NOTES

NOTES

NOTES